Country Garden

Morgan Fitzsimons

copyright Morgan Fitzsimons 2016
All rights reserved by artist

Fae Entertainment & Fae Workshop

www.morganfitzsimons.com
info@fae-entertainment.ca

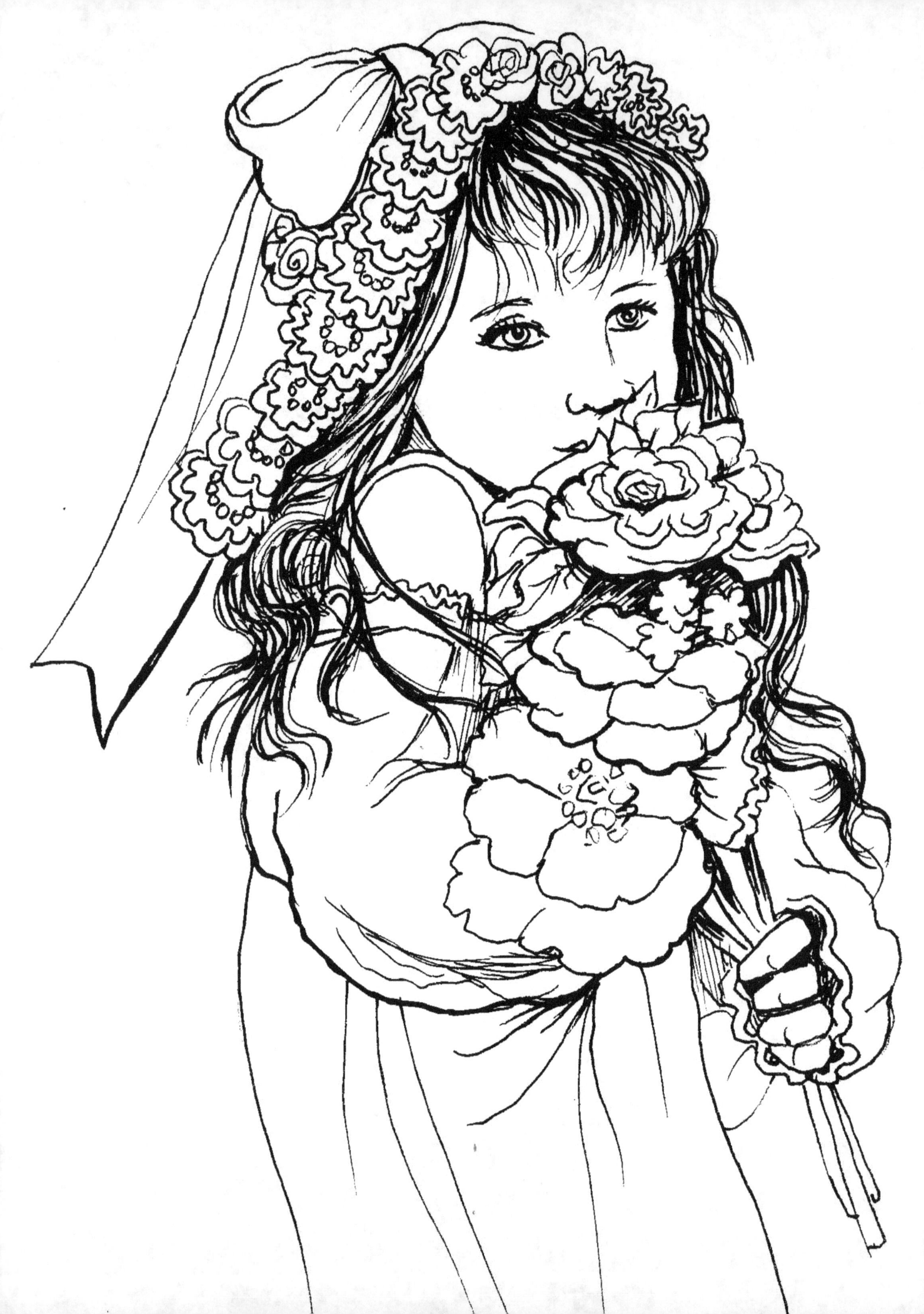

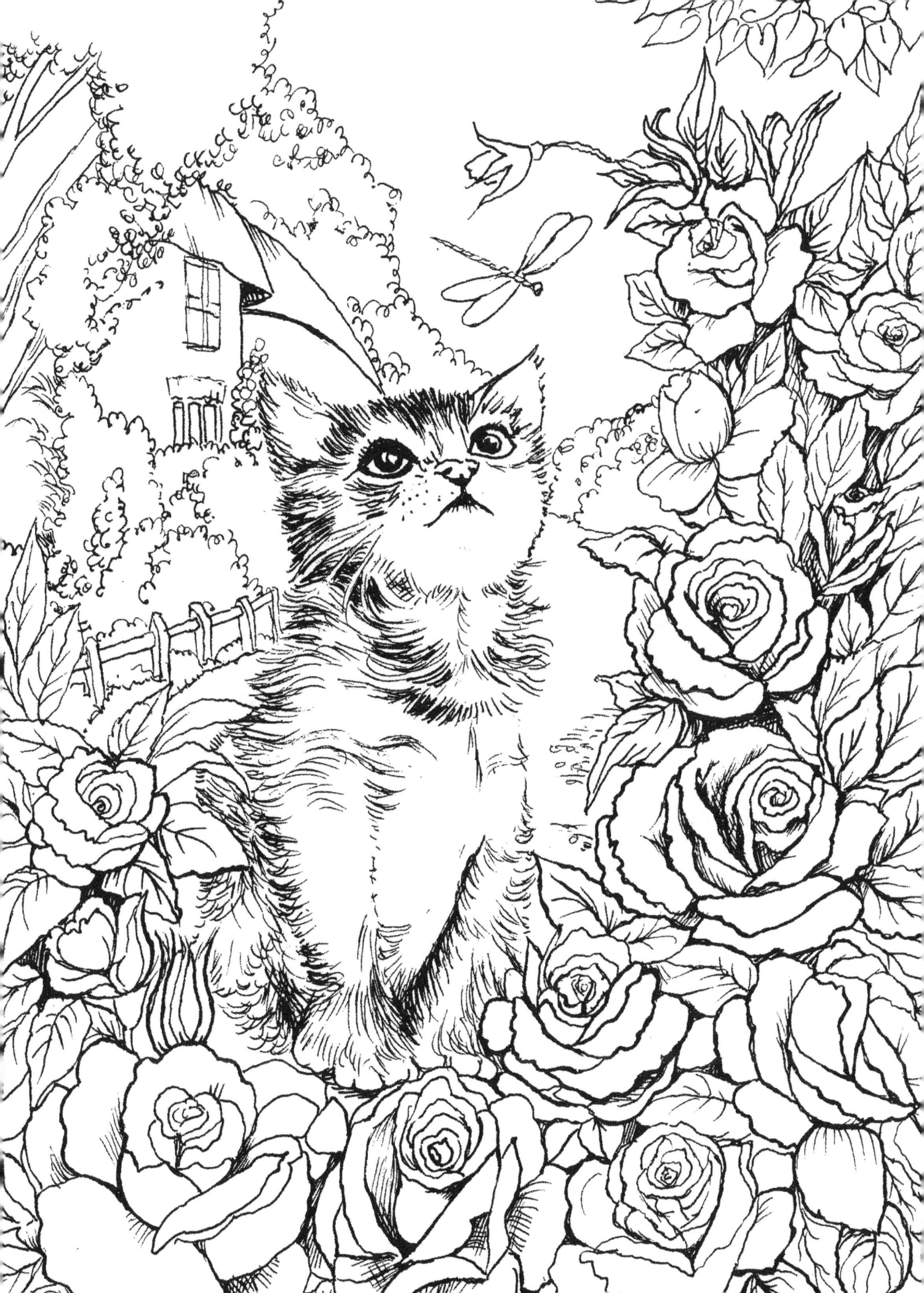

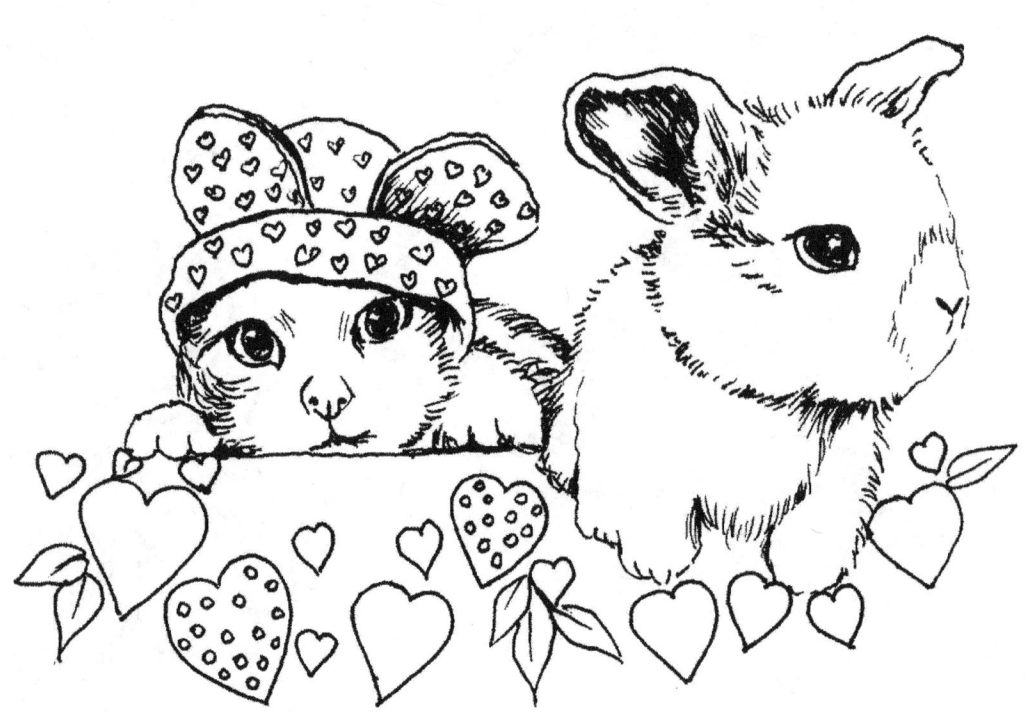

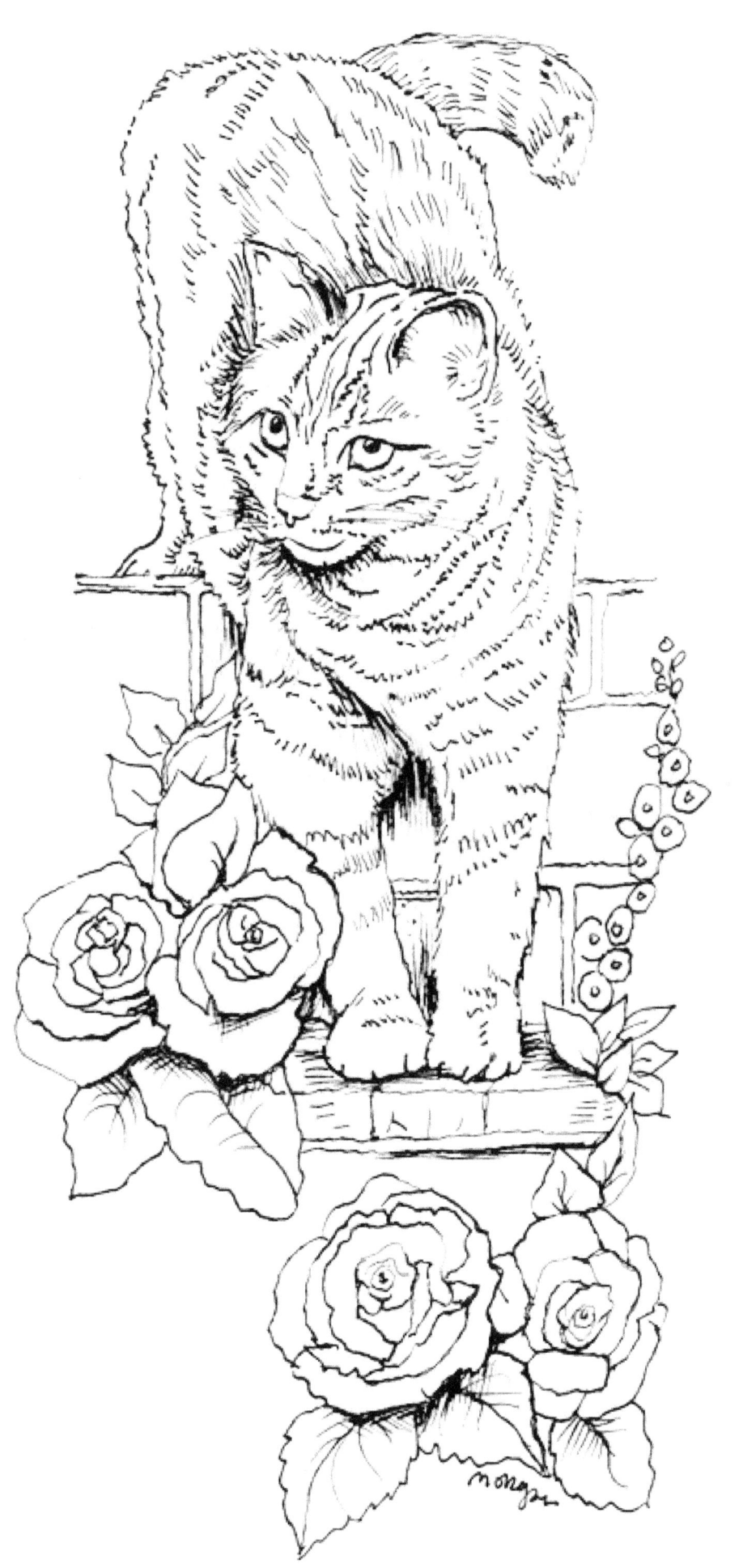

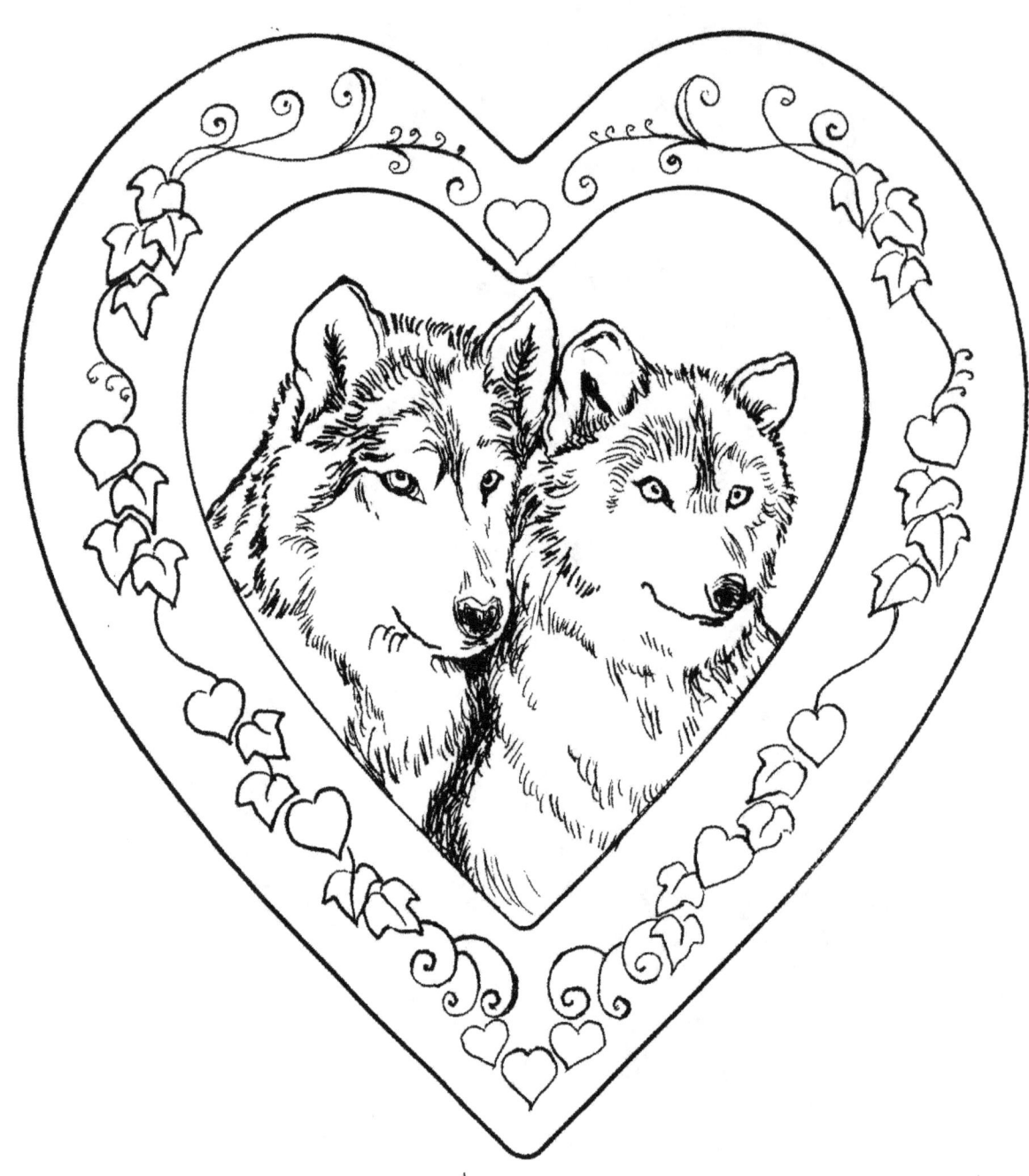

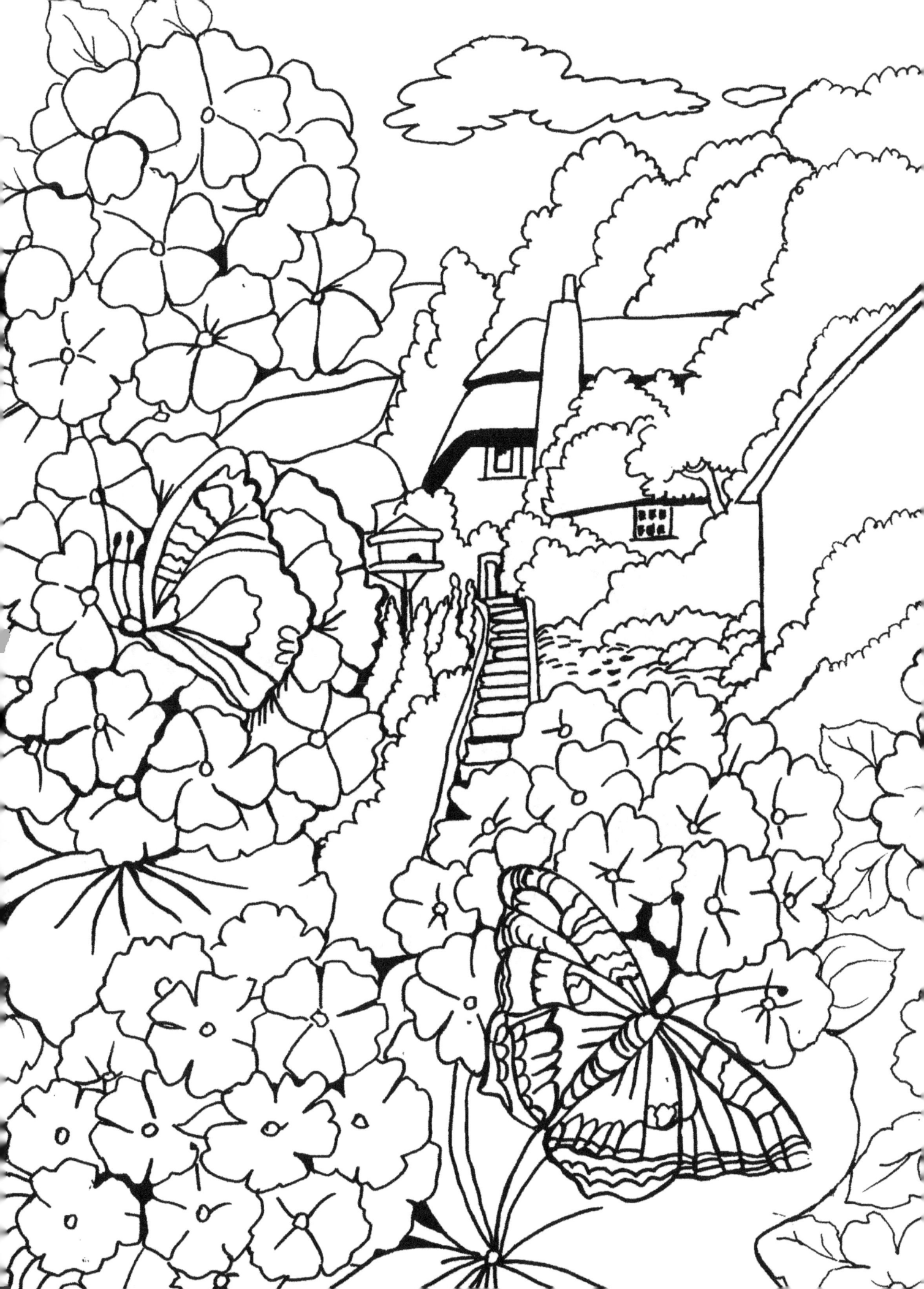

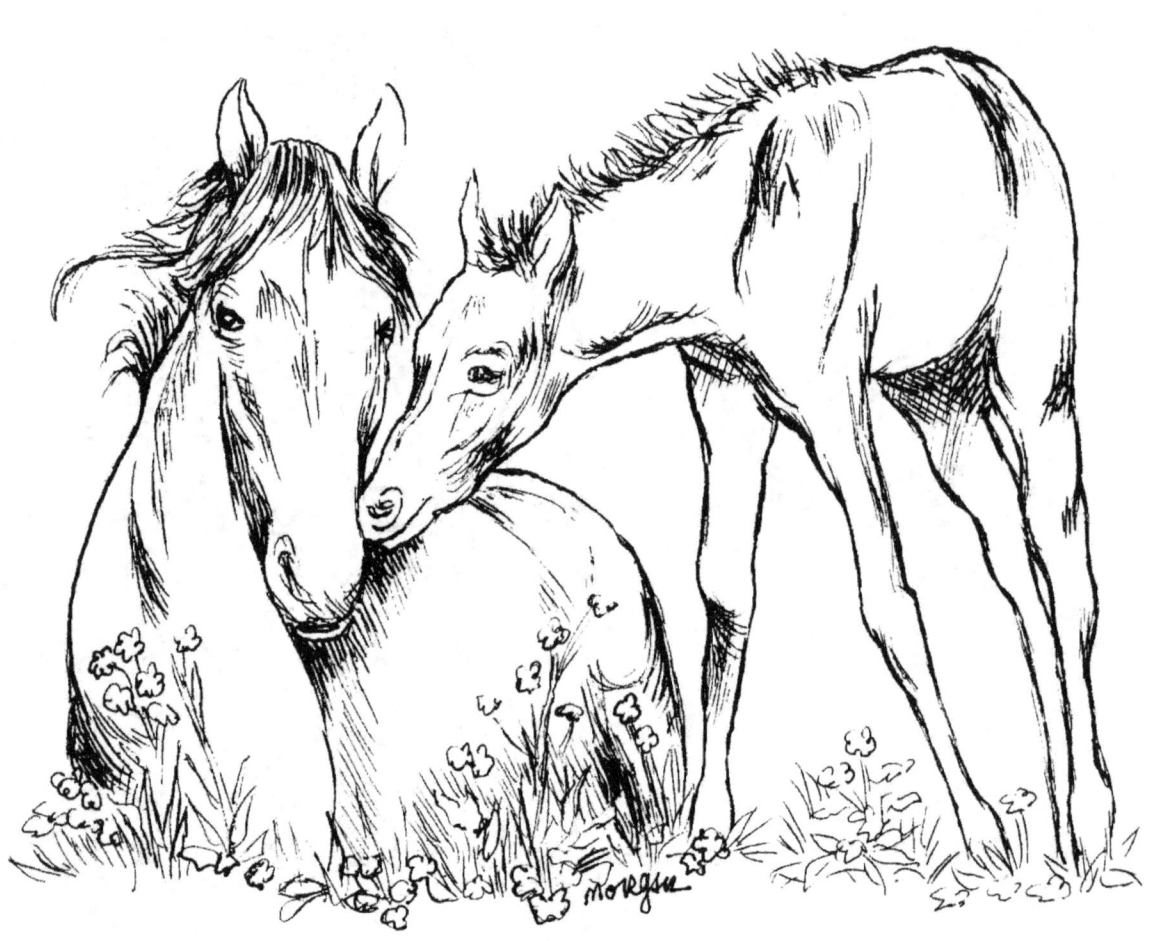

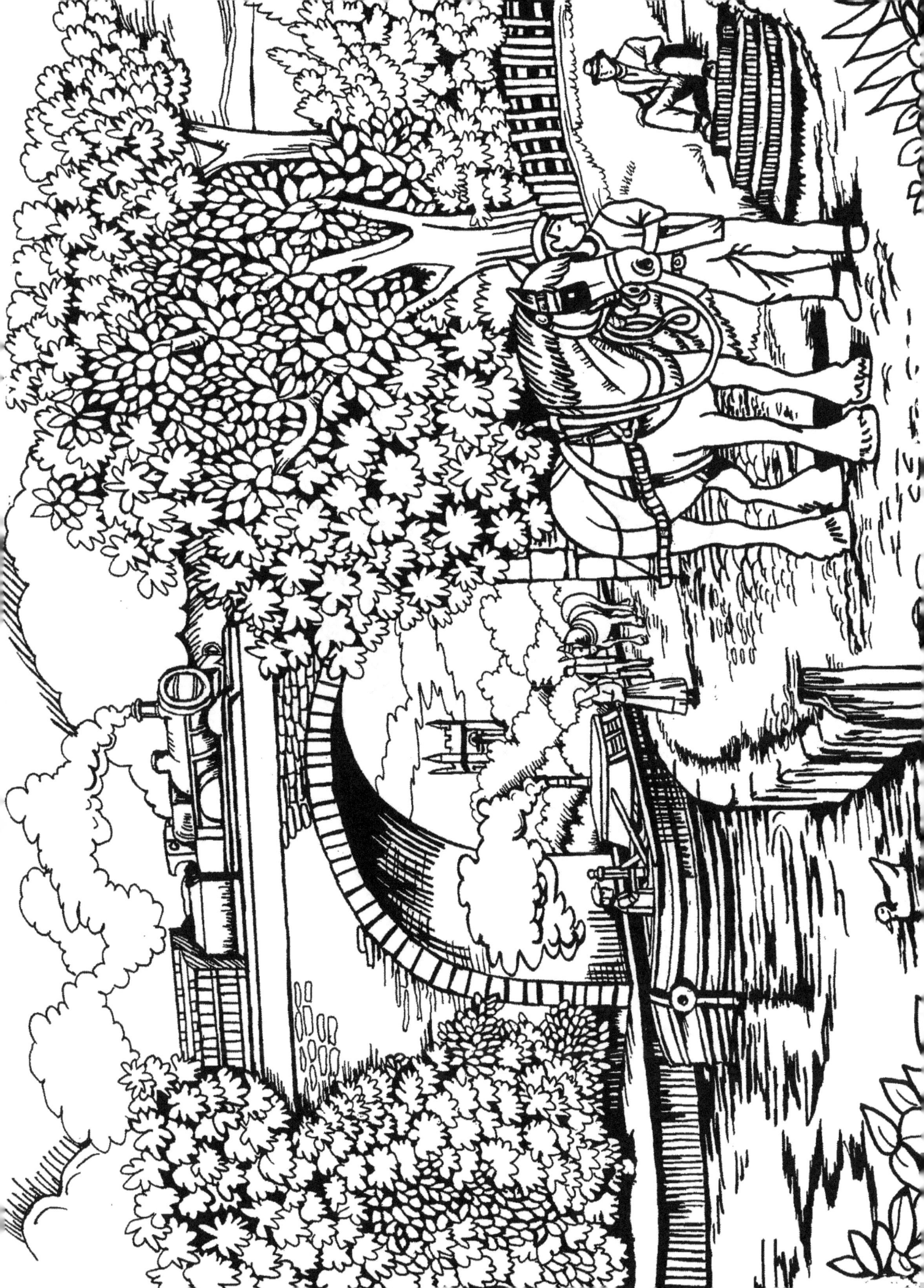

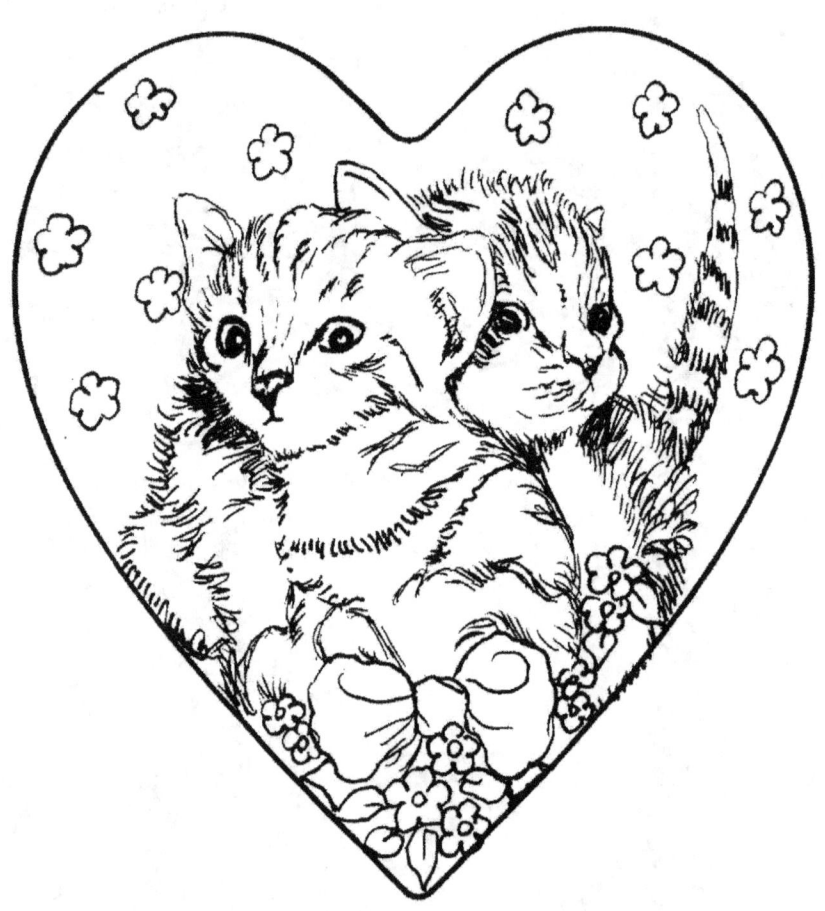

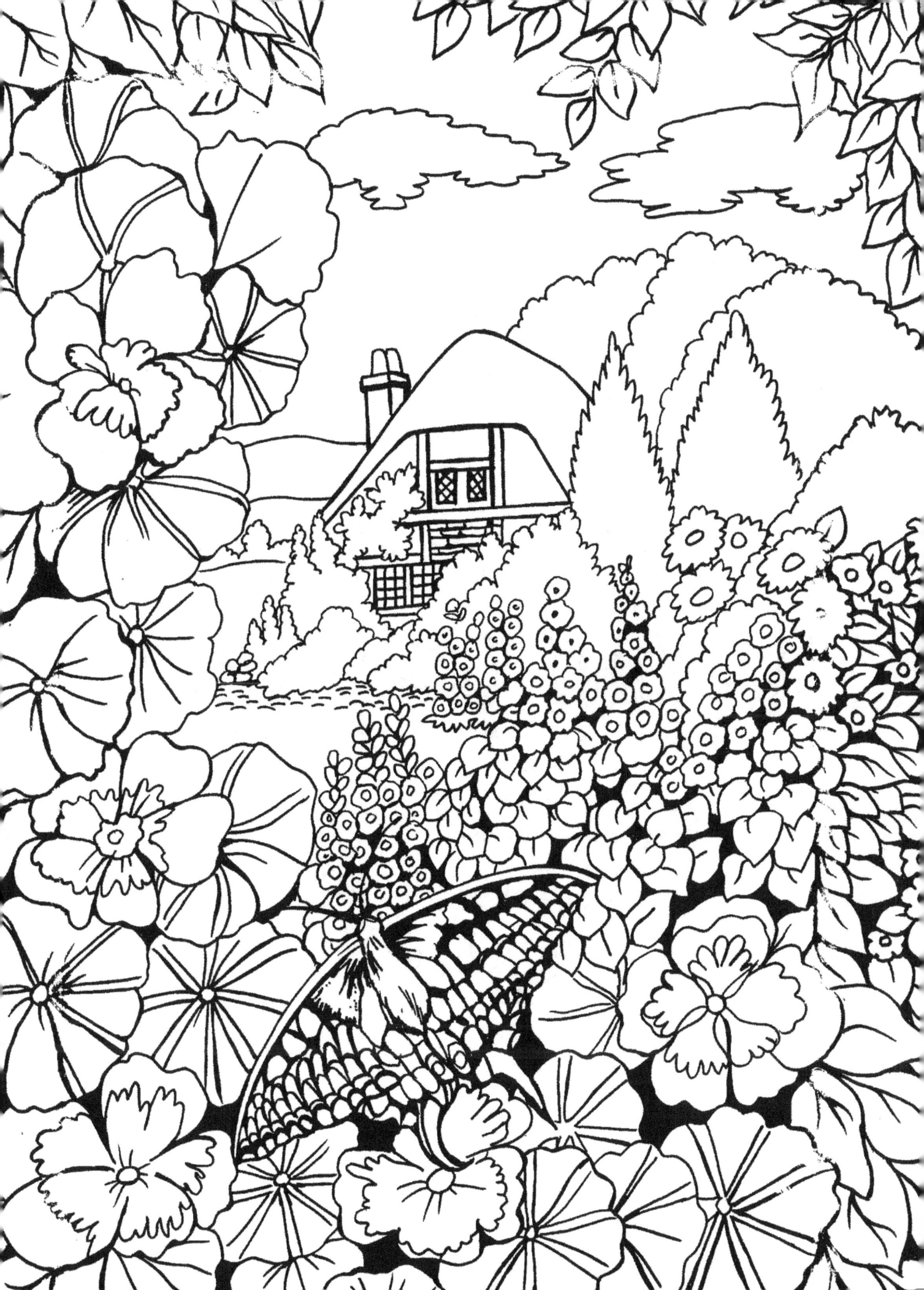

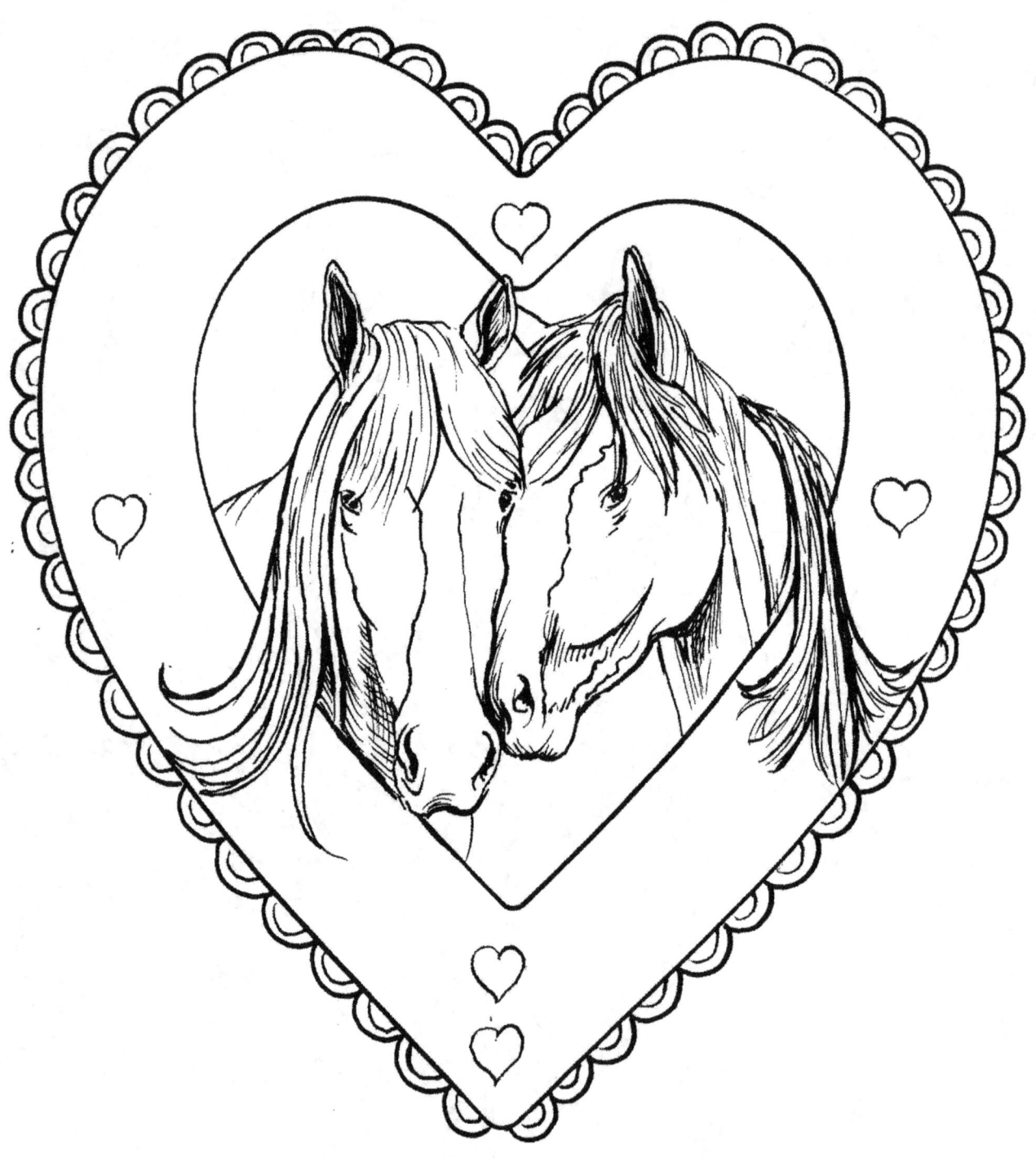

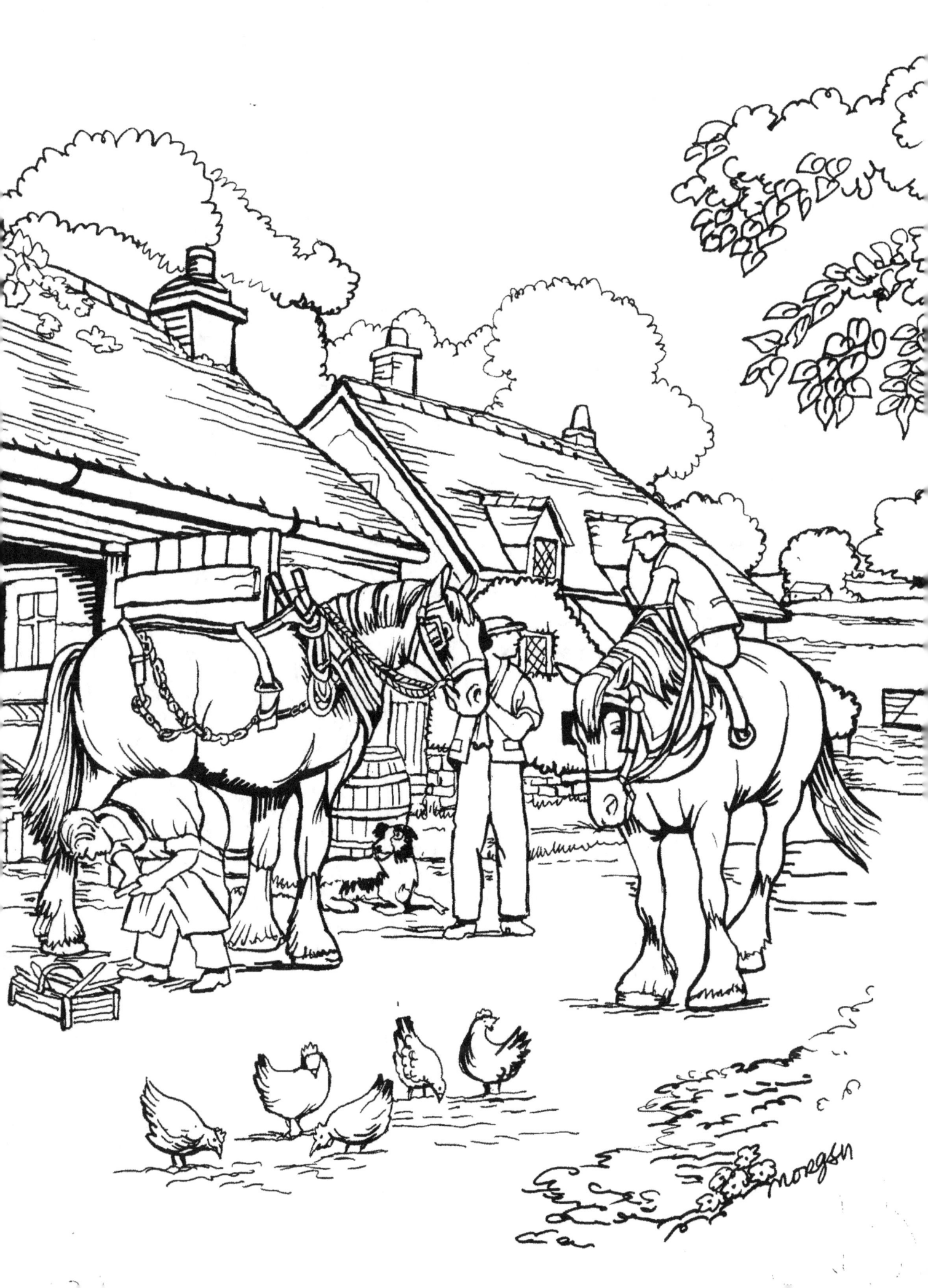

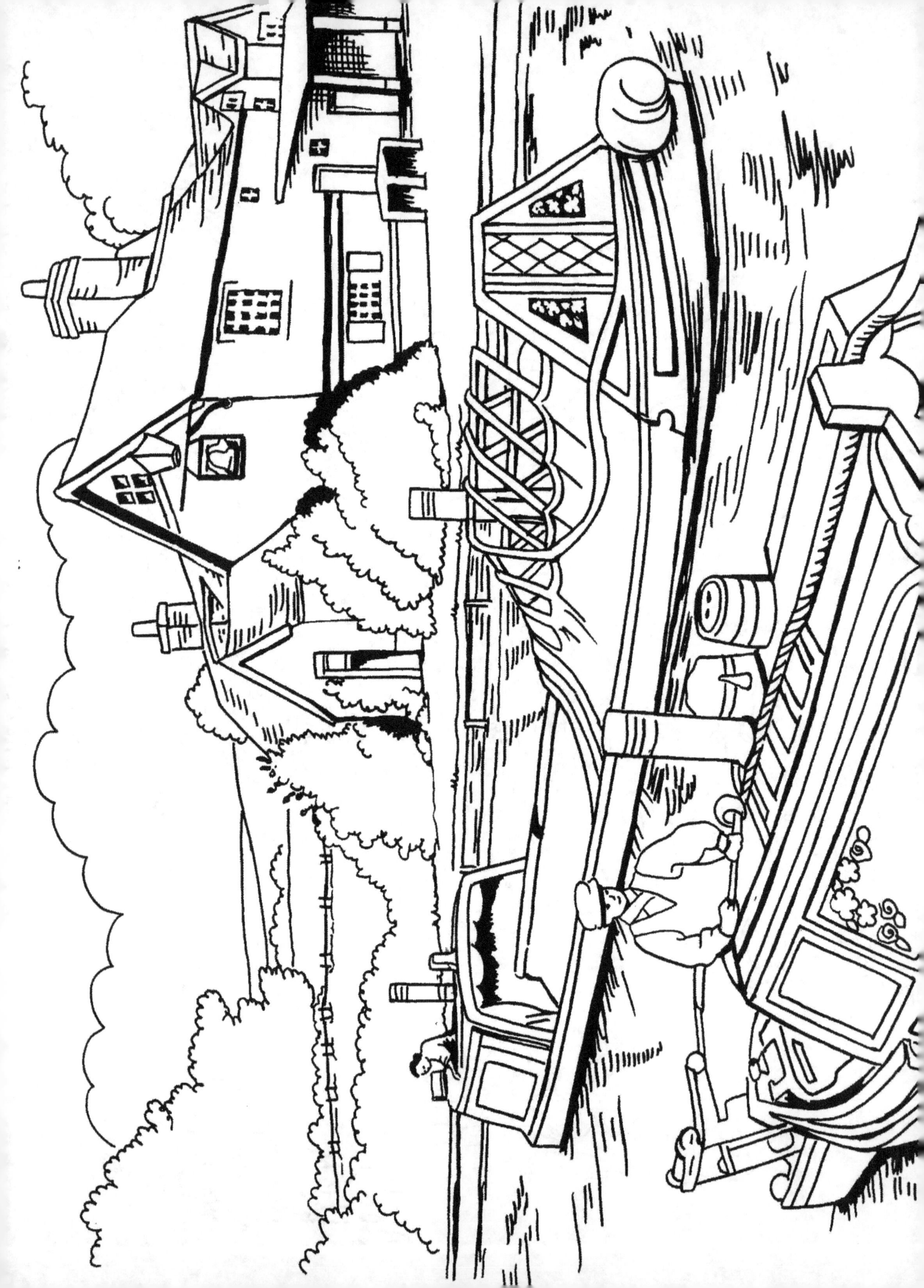

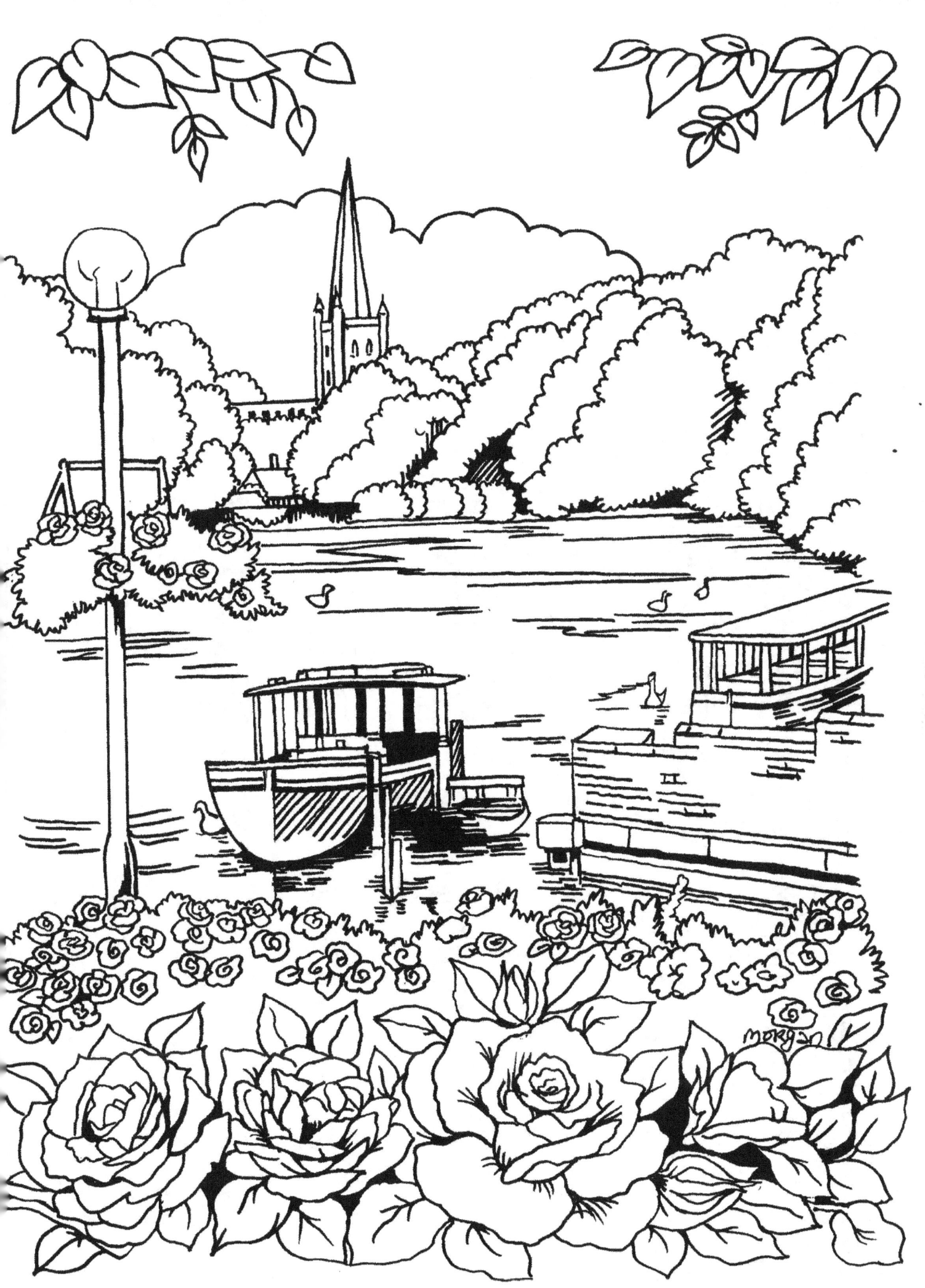

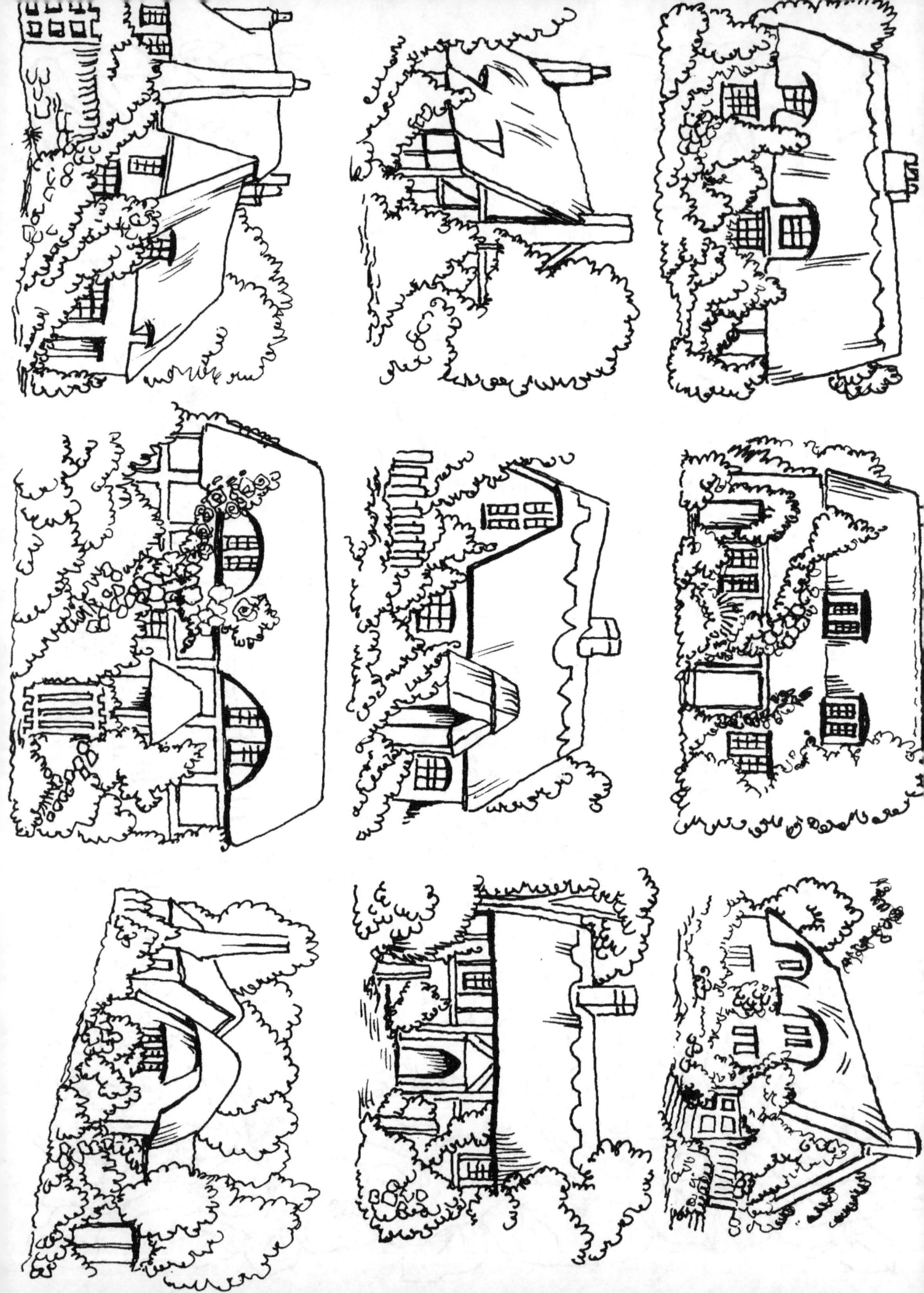

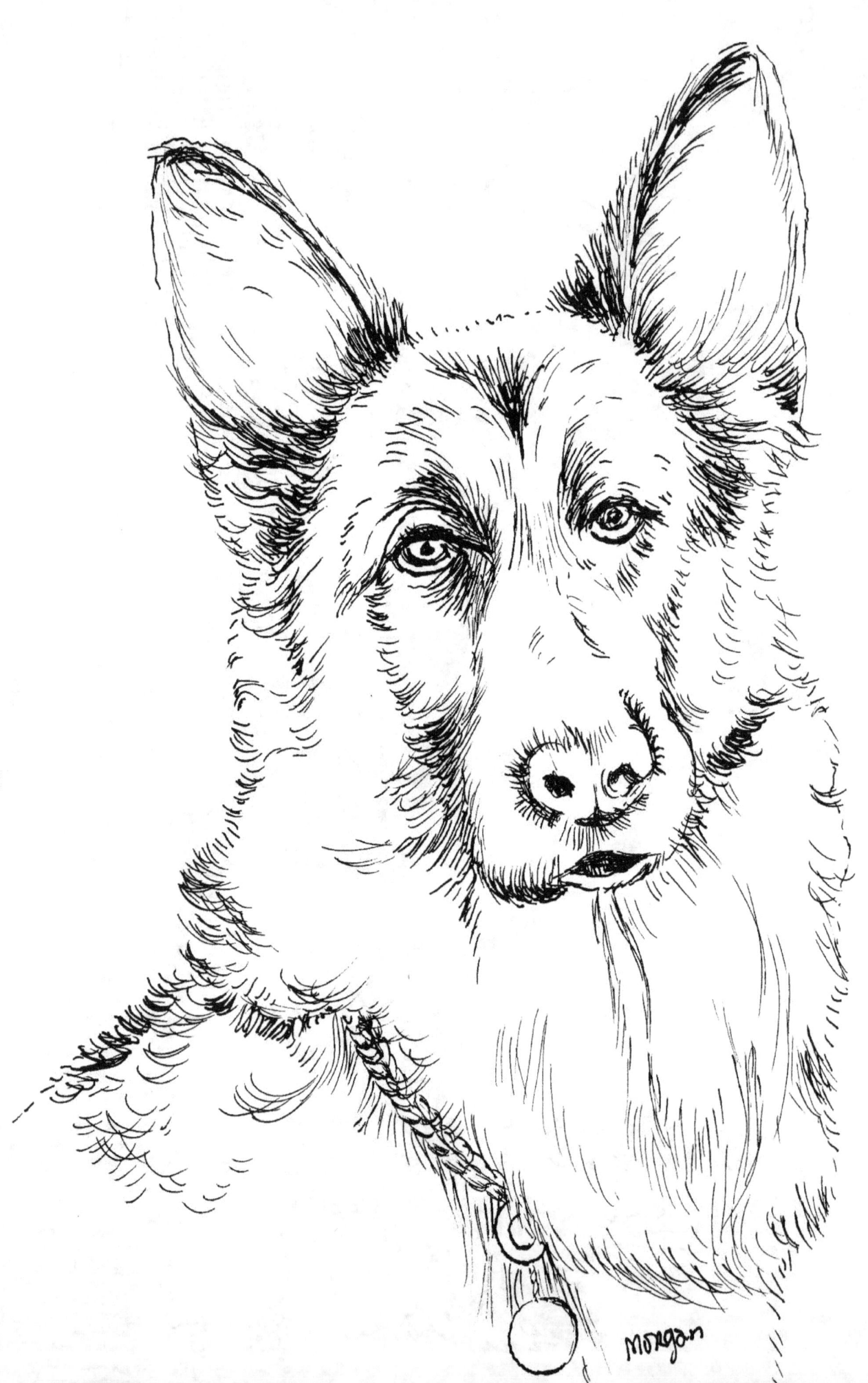

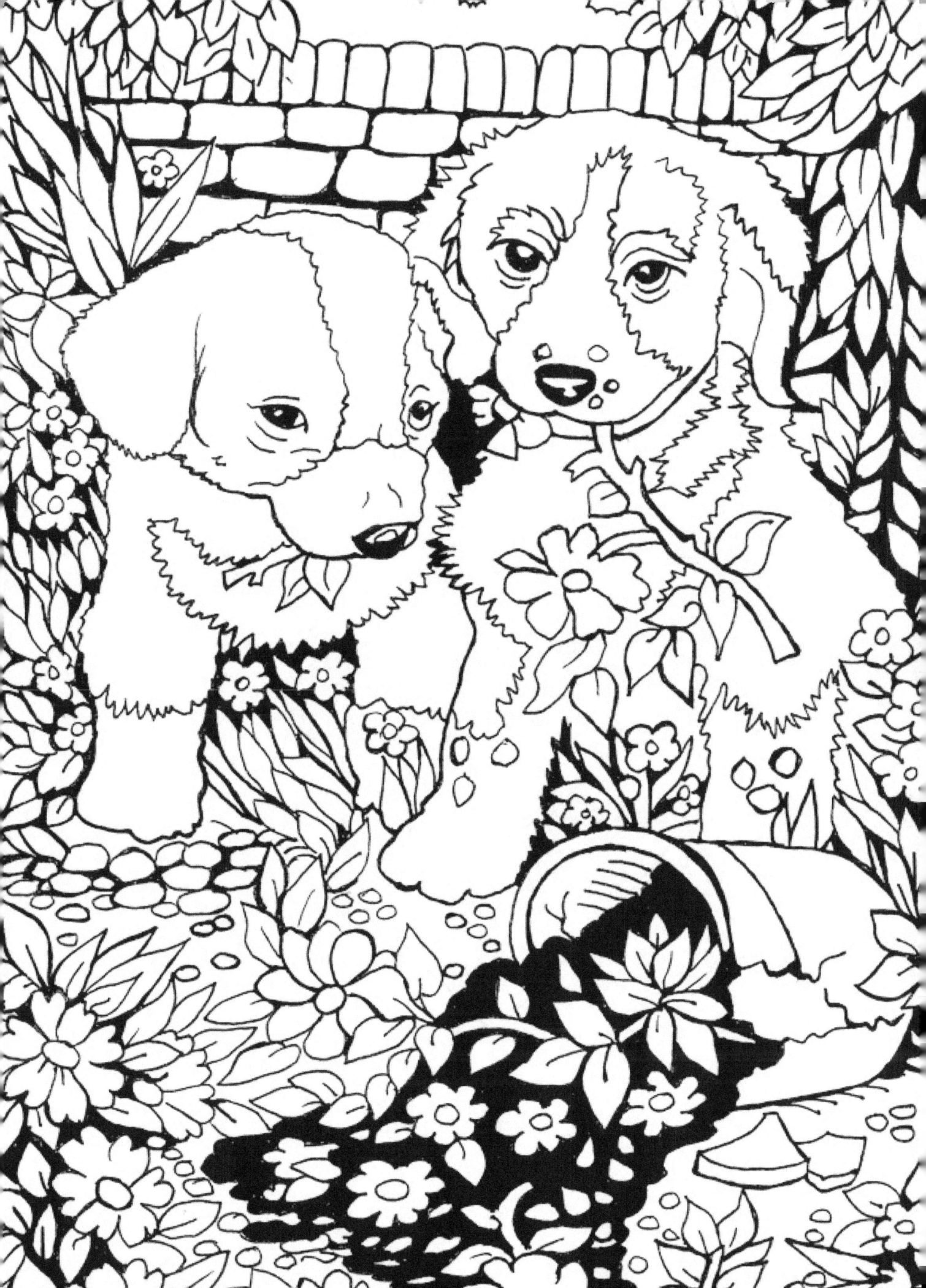

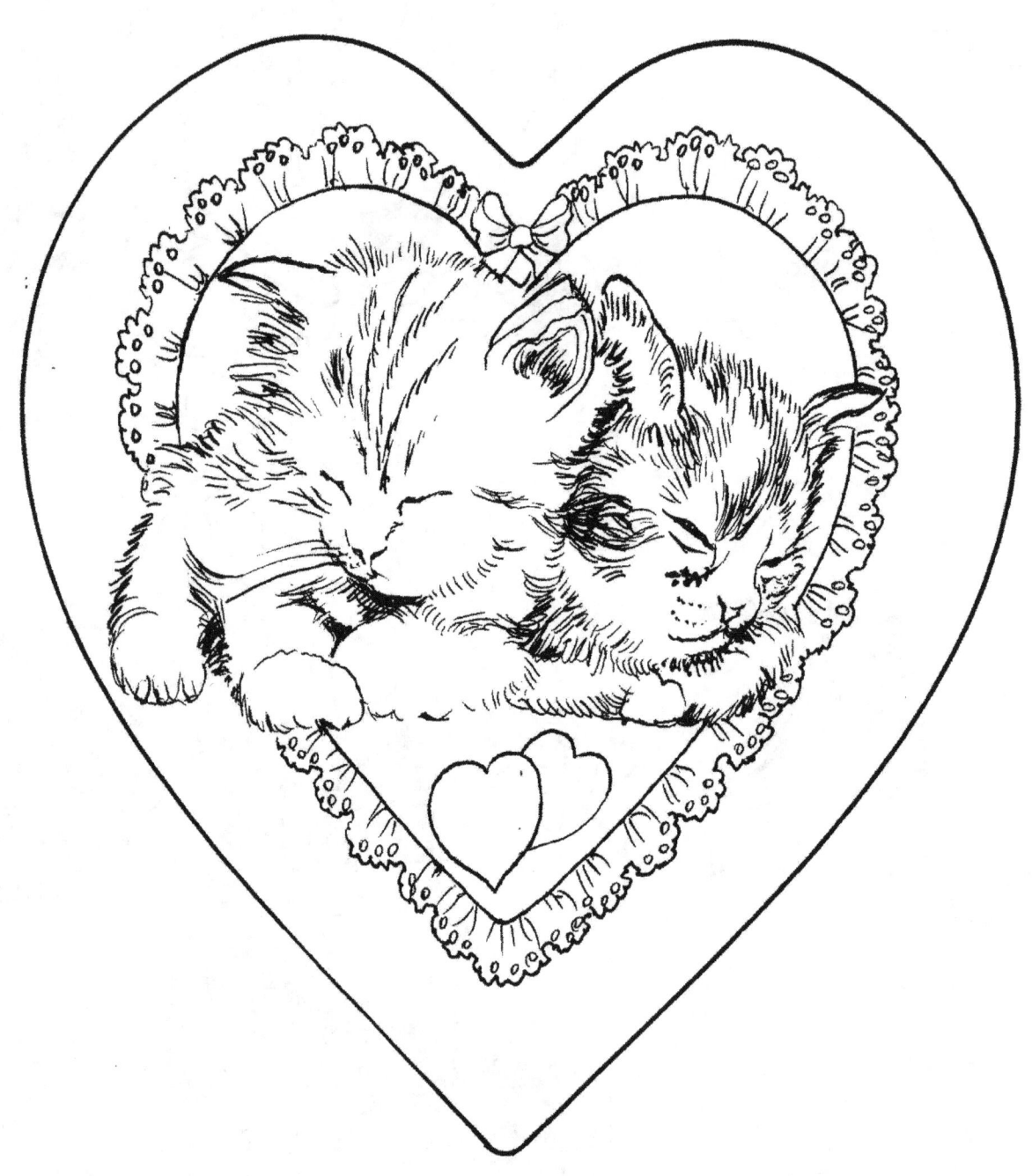

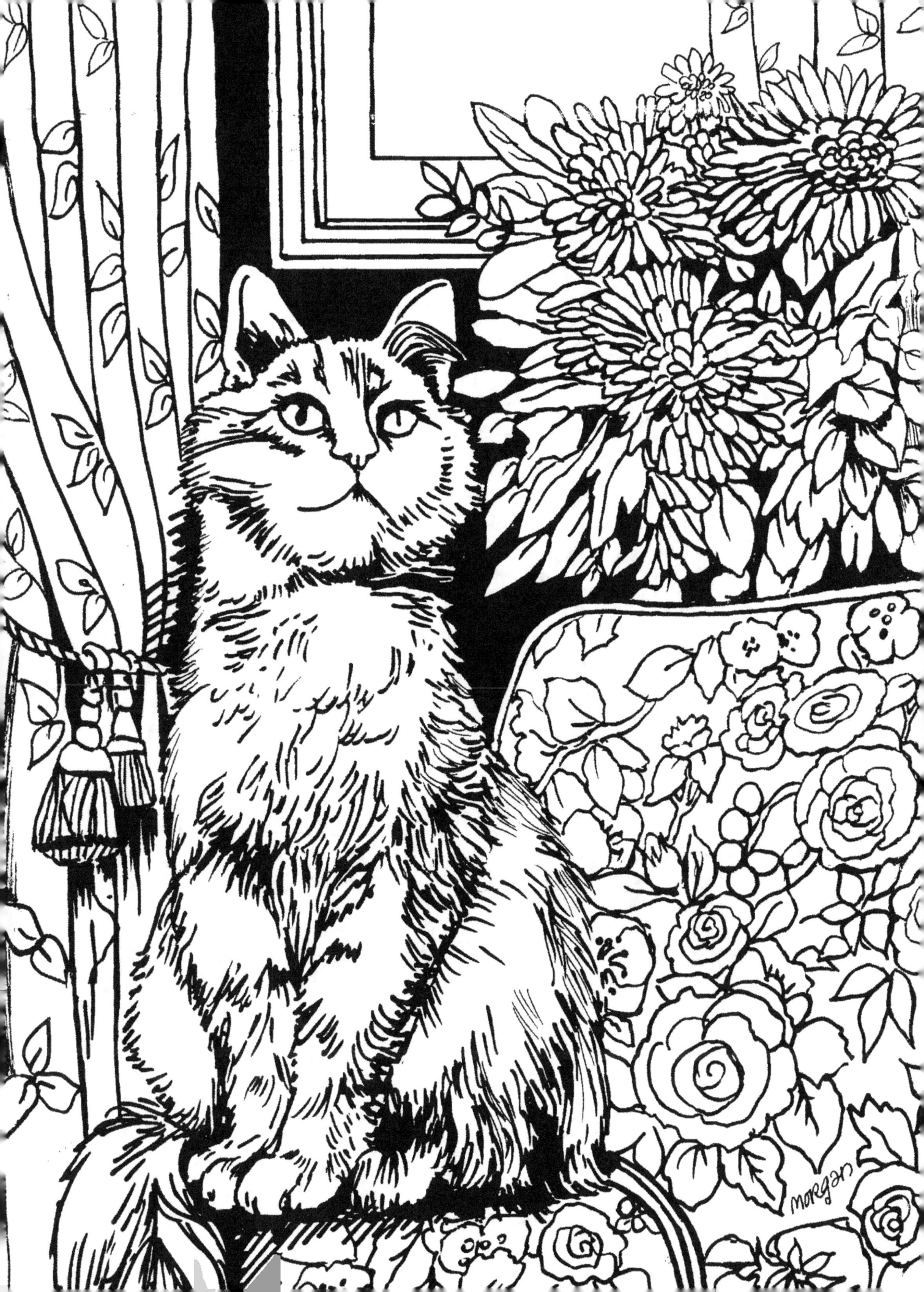

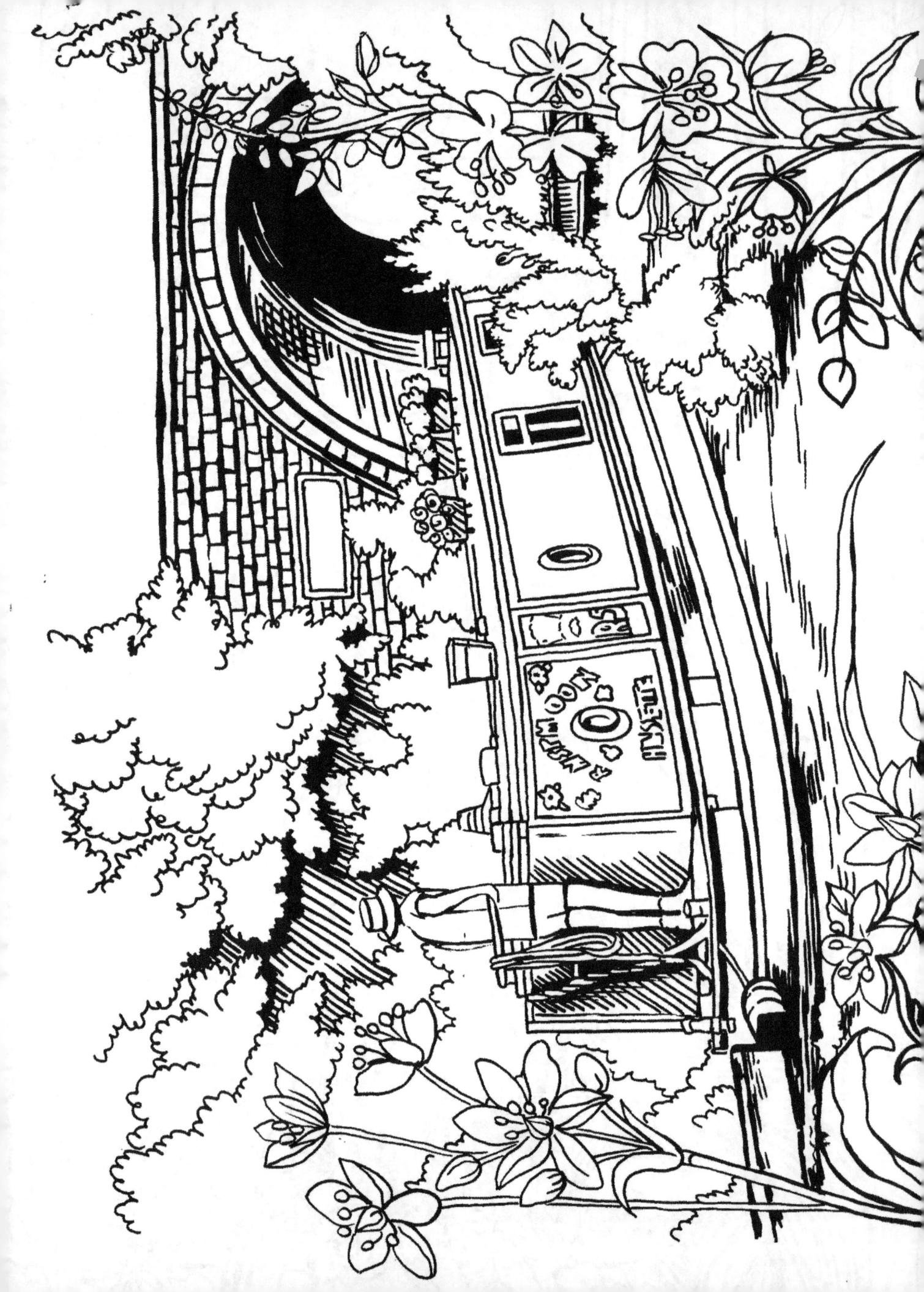

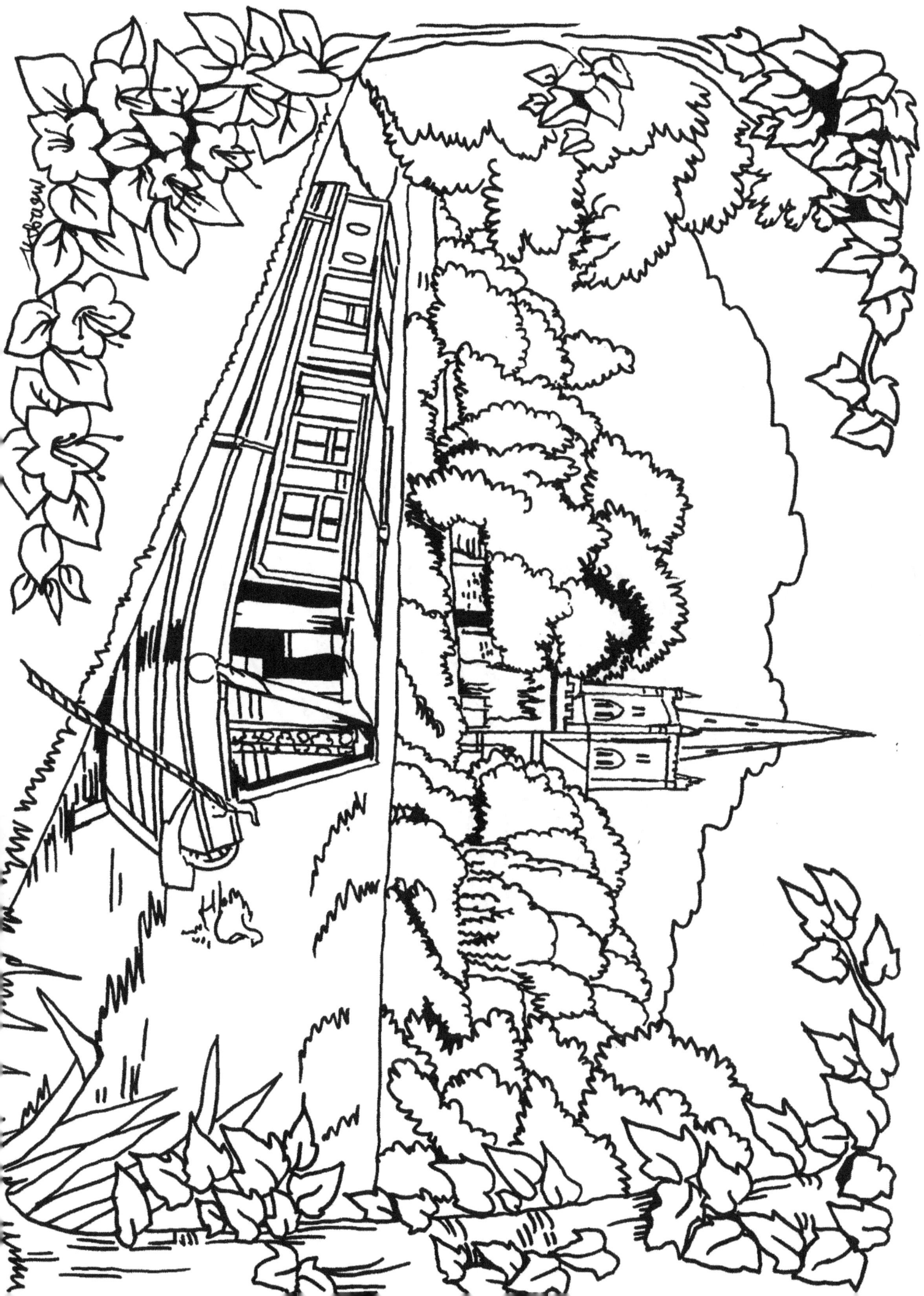

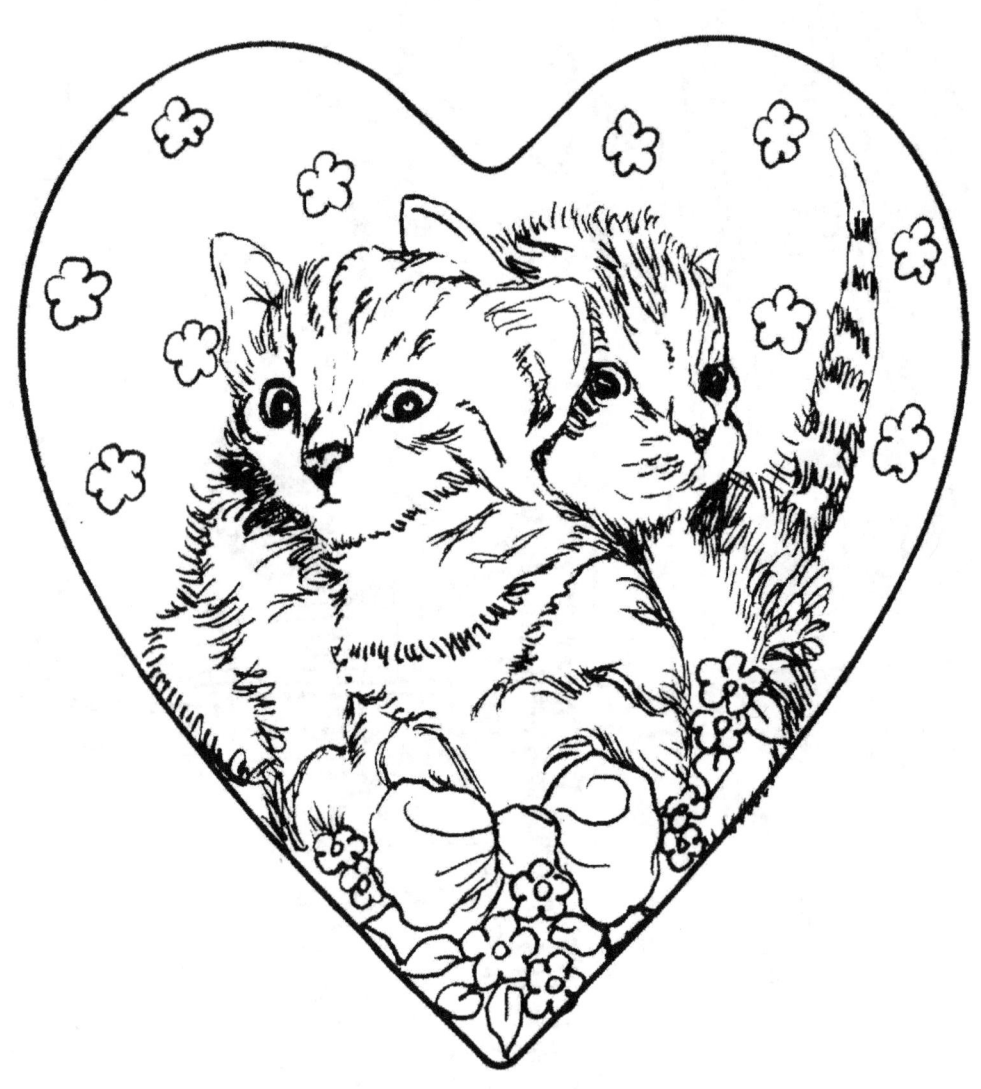

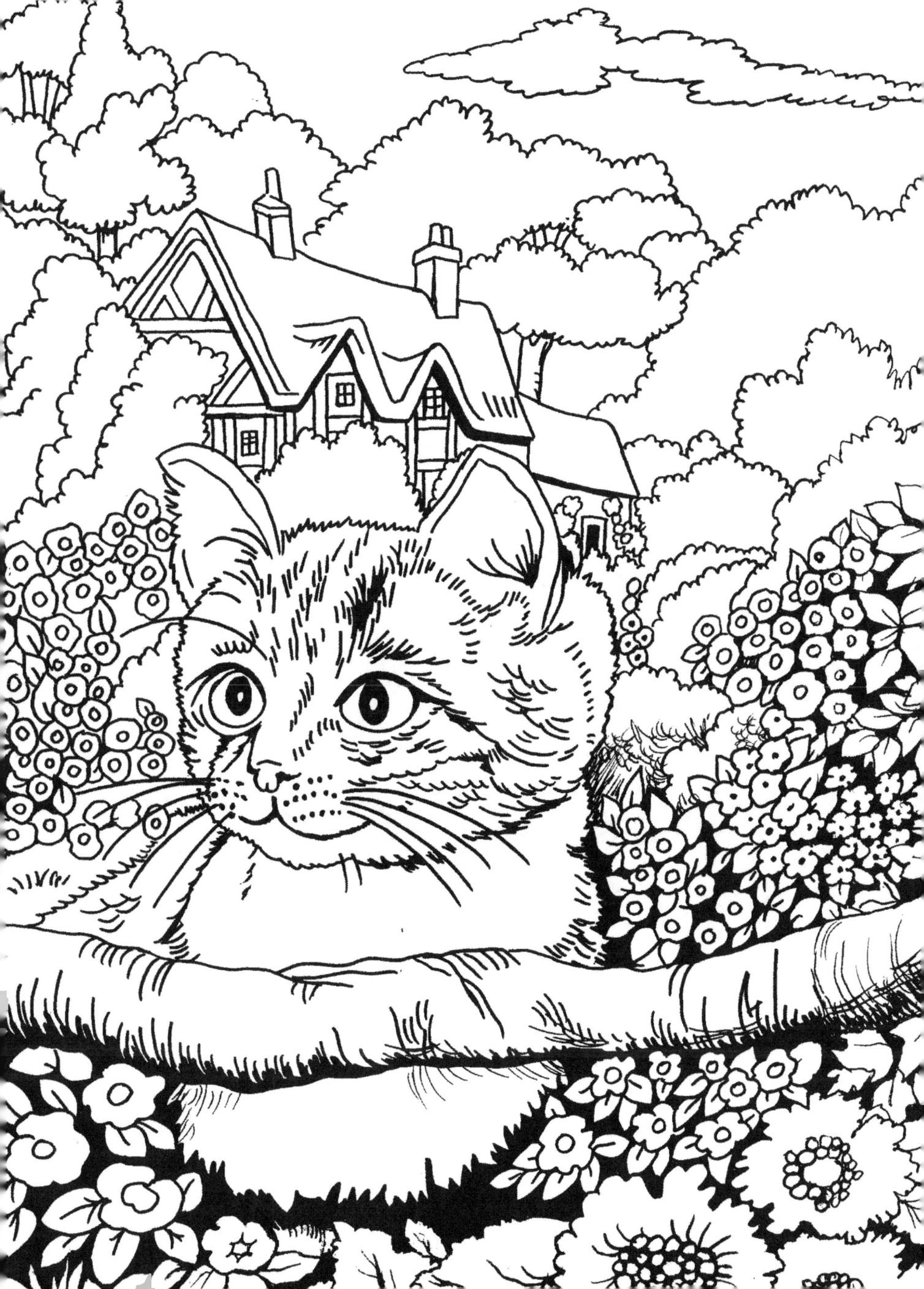

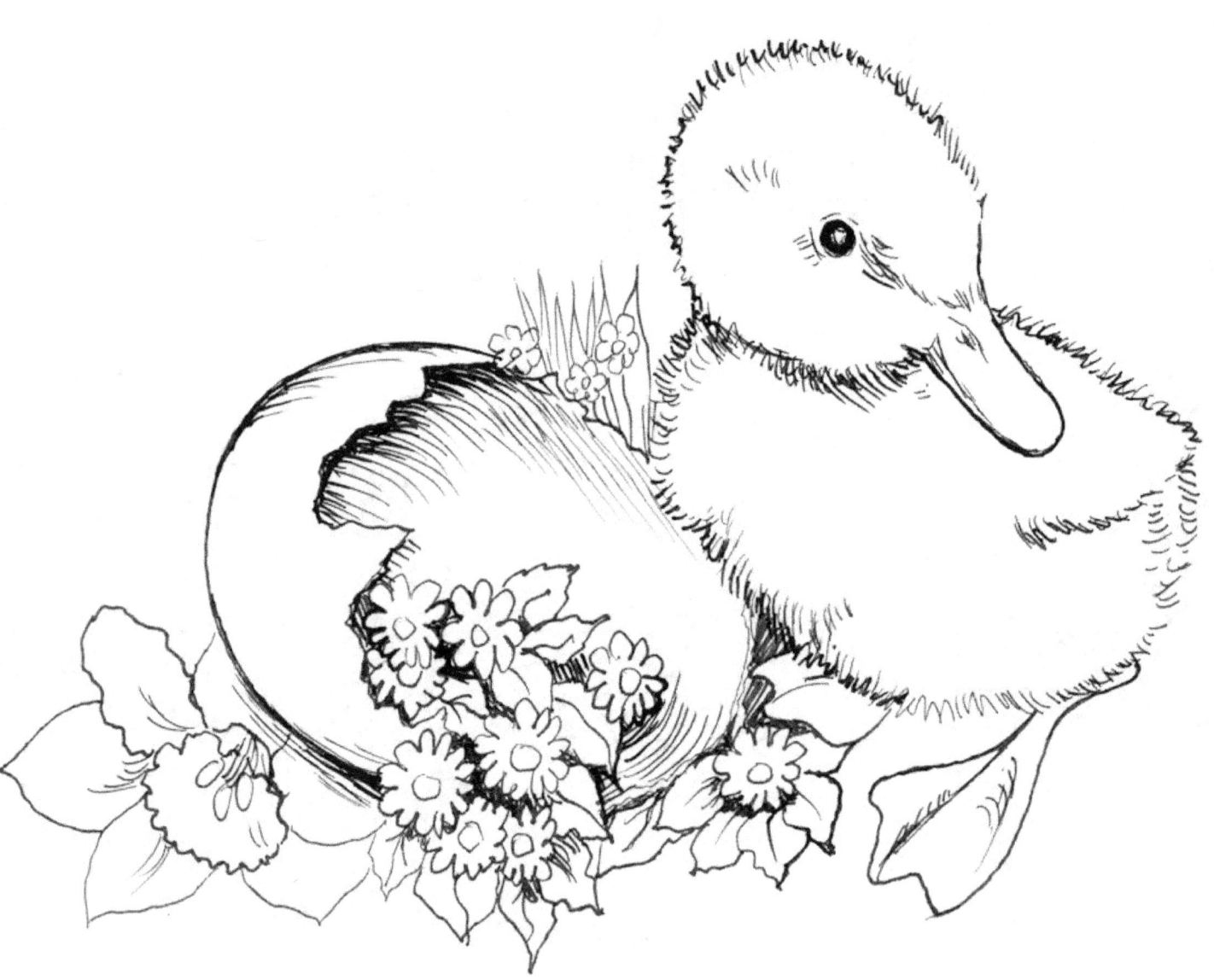

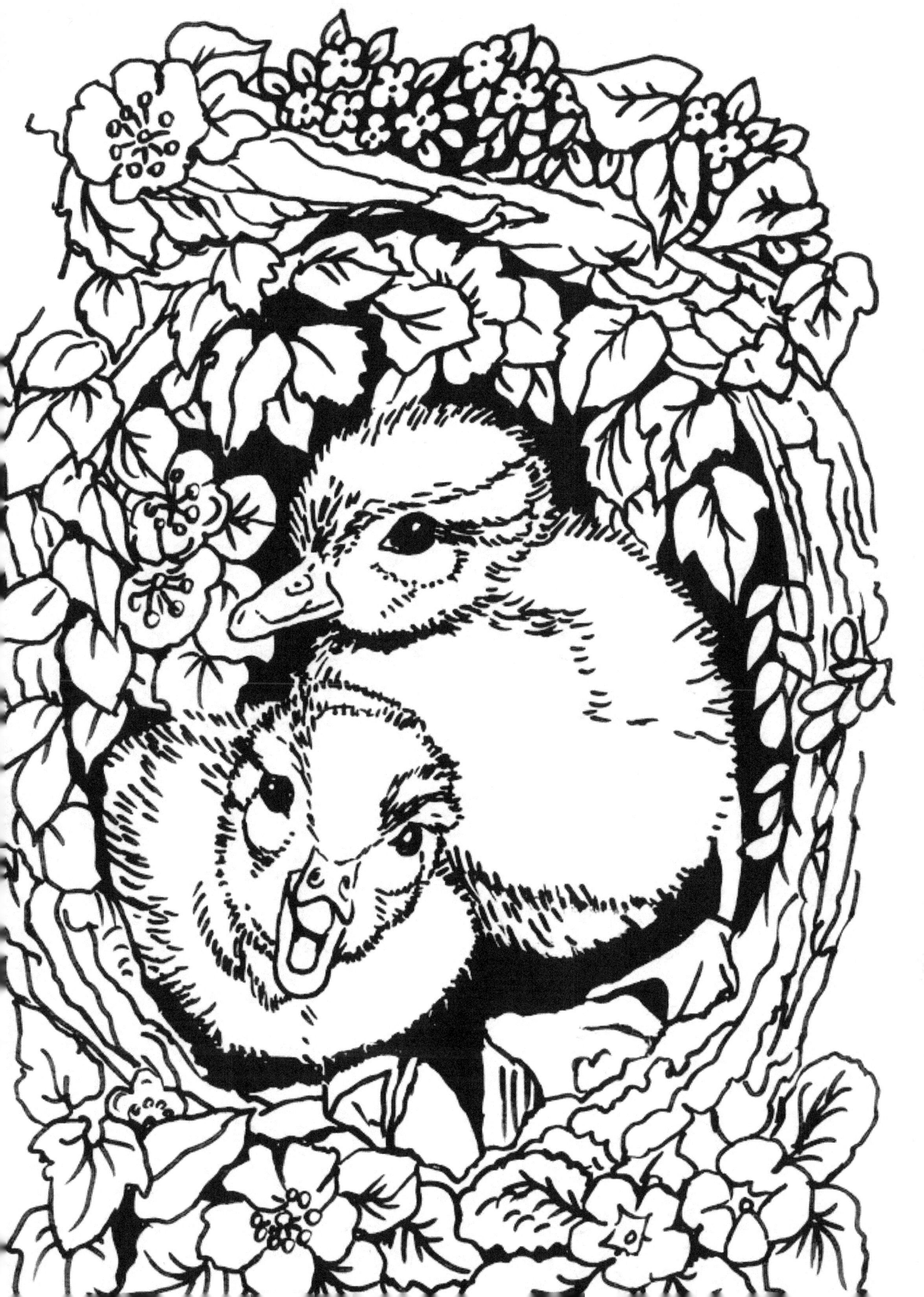

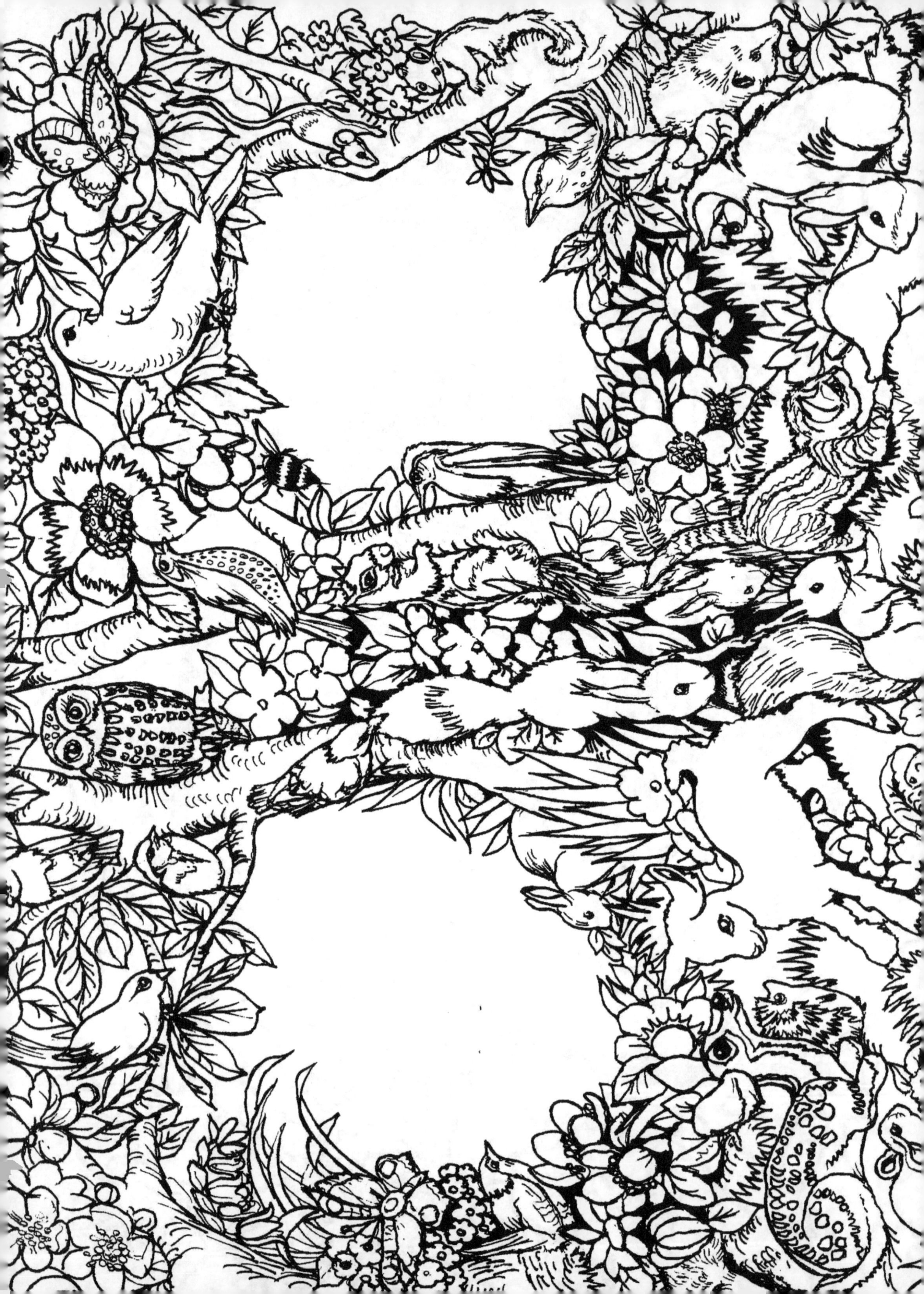

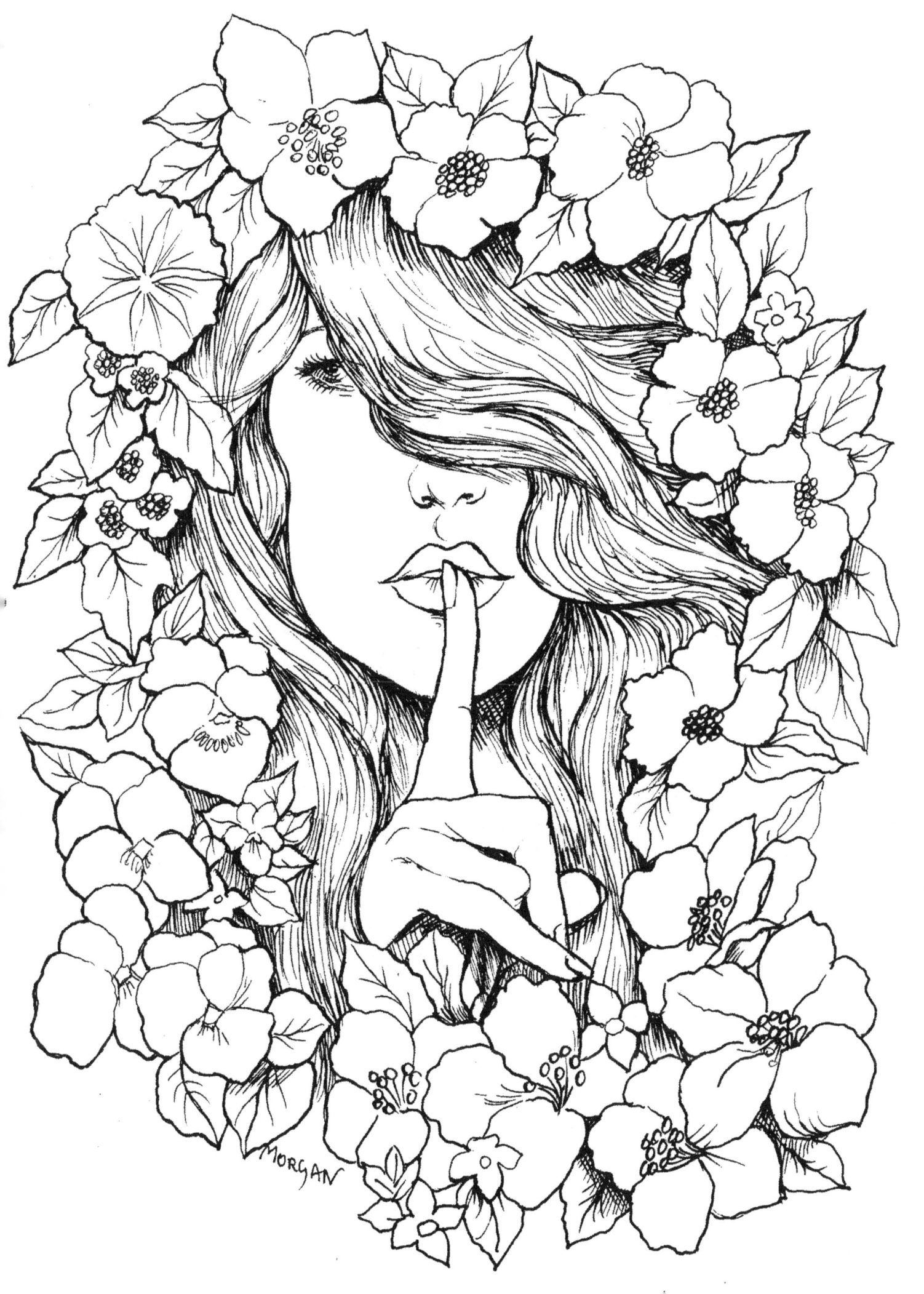

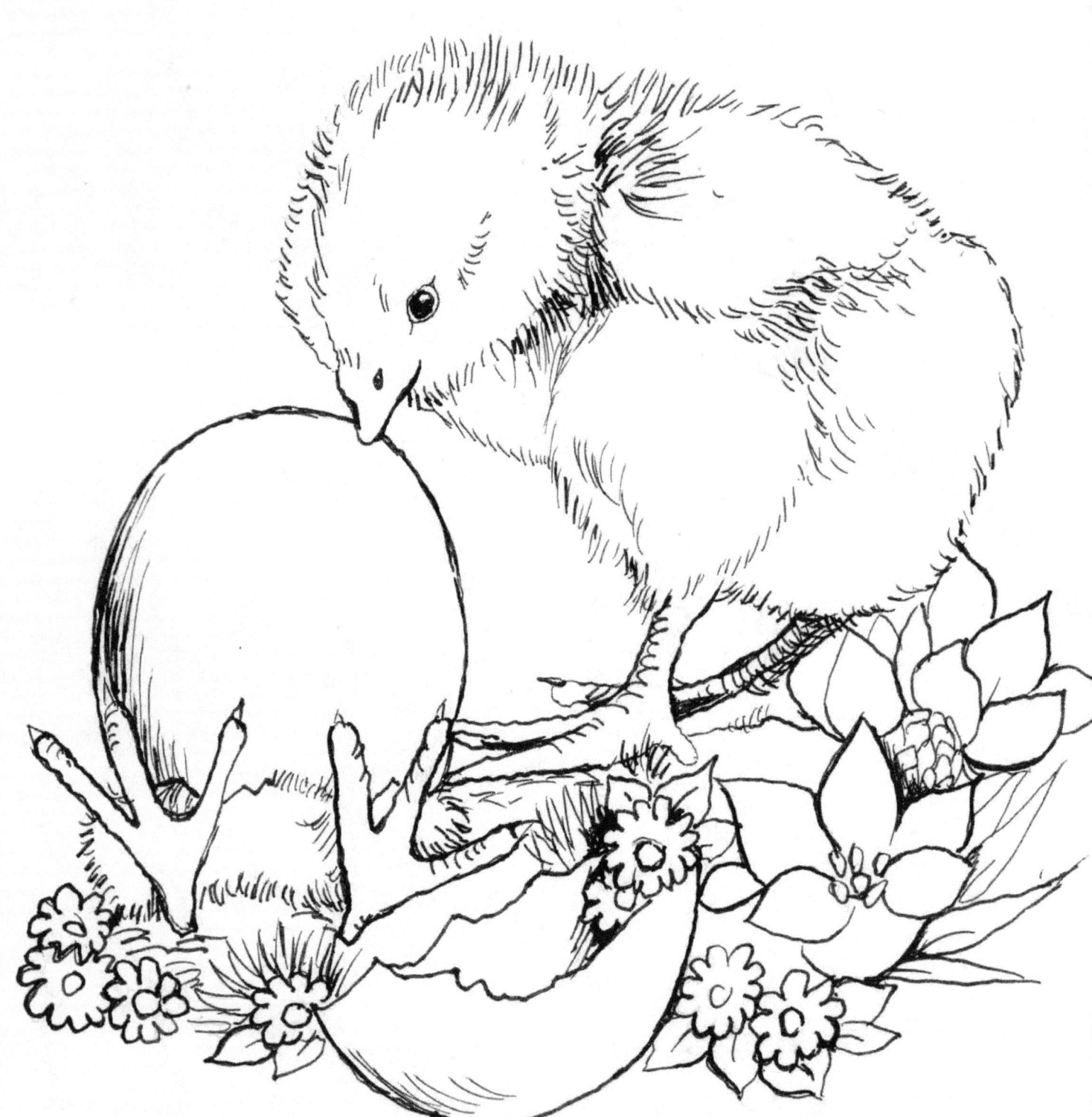

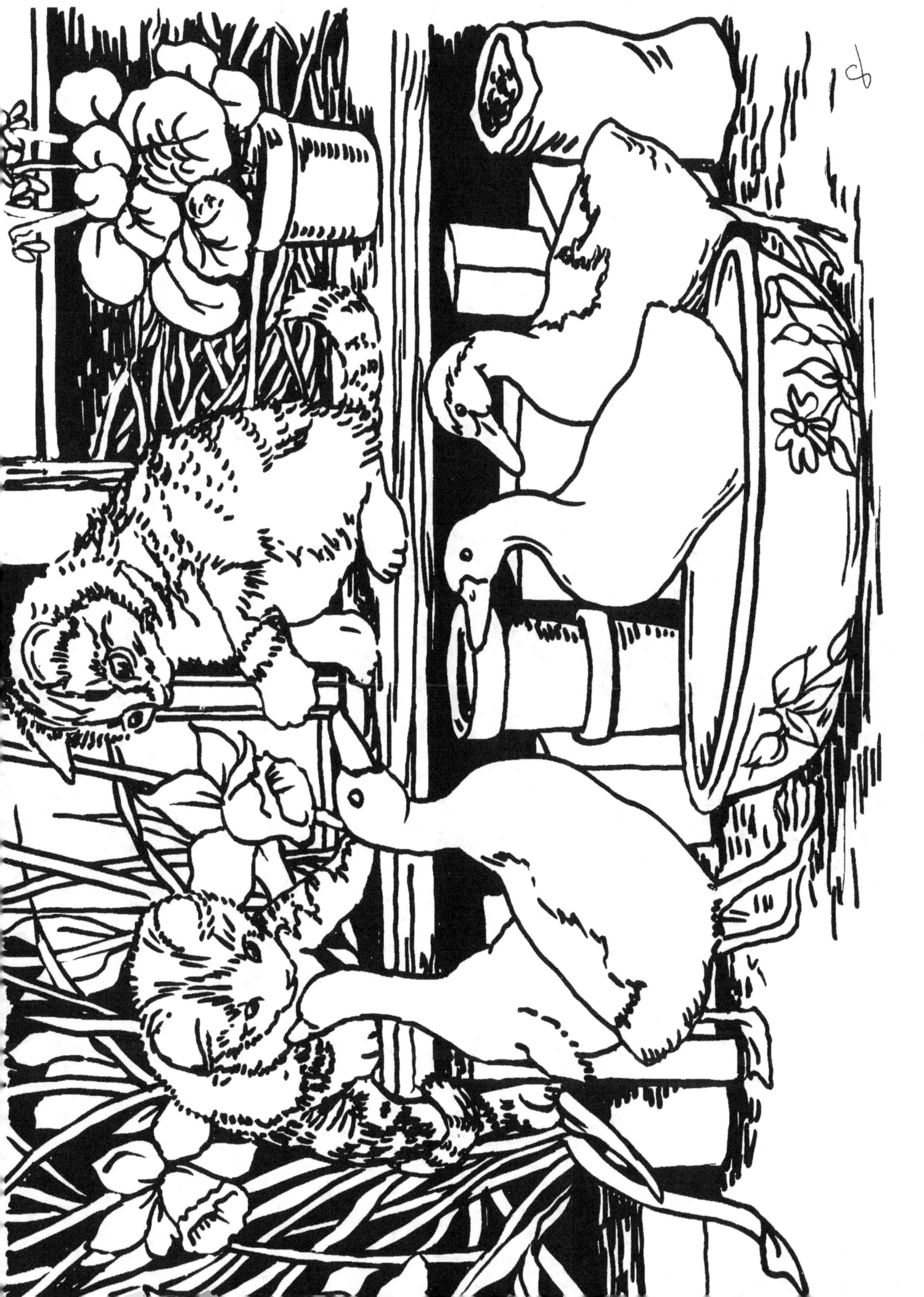

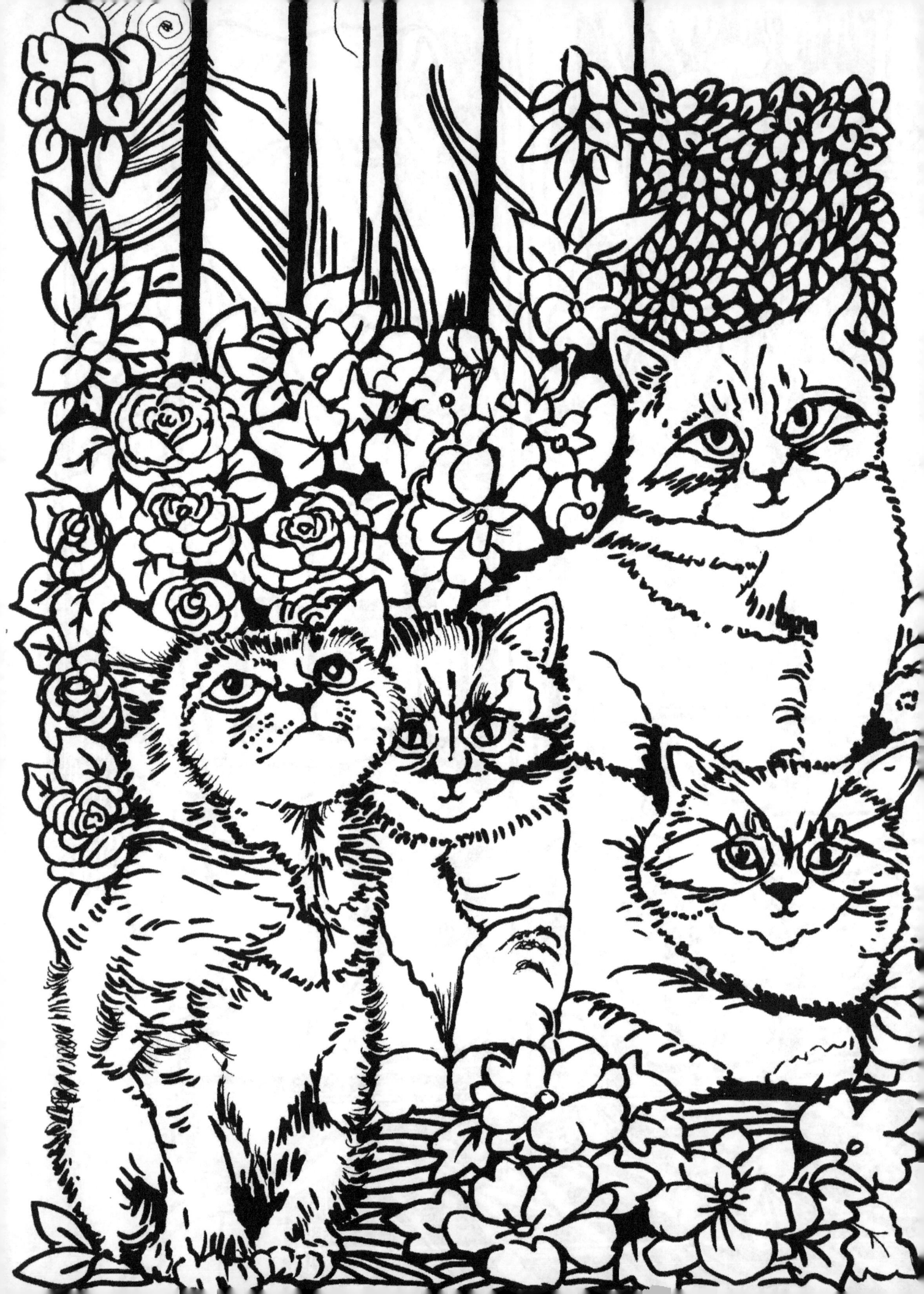

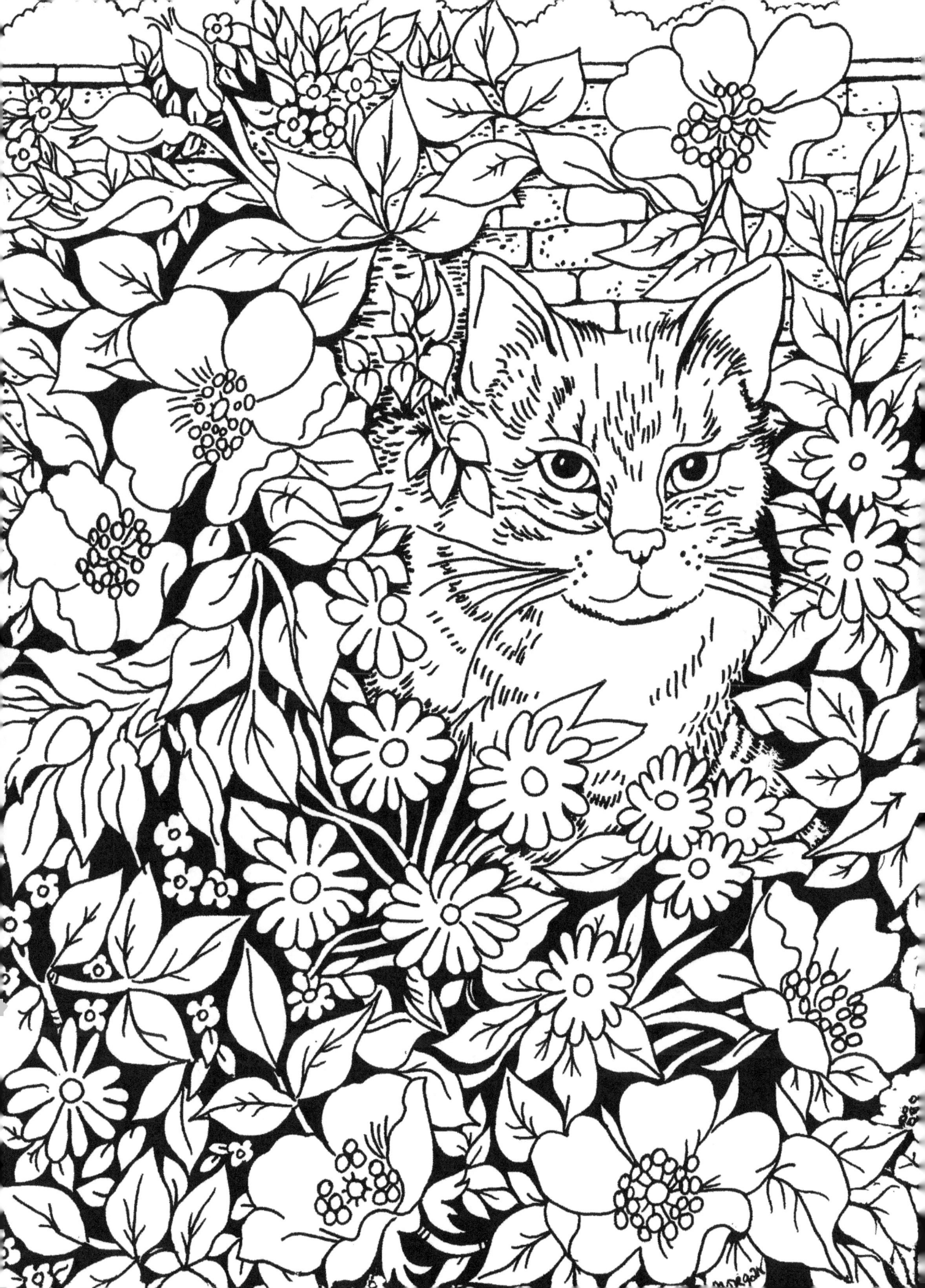

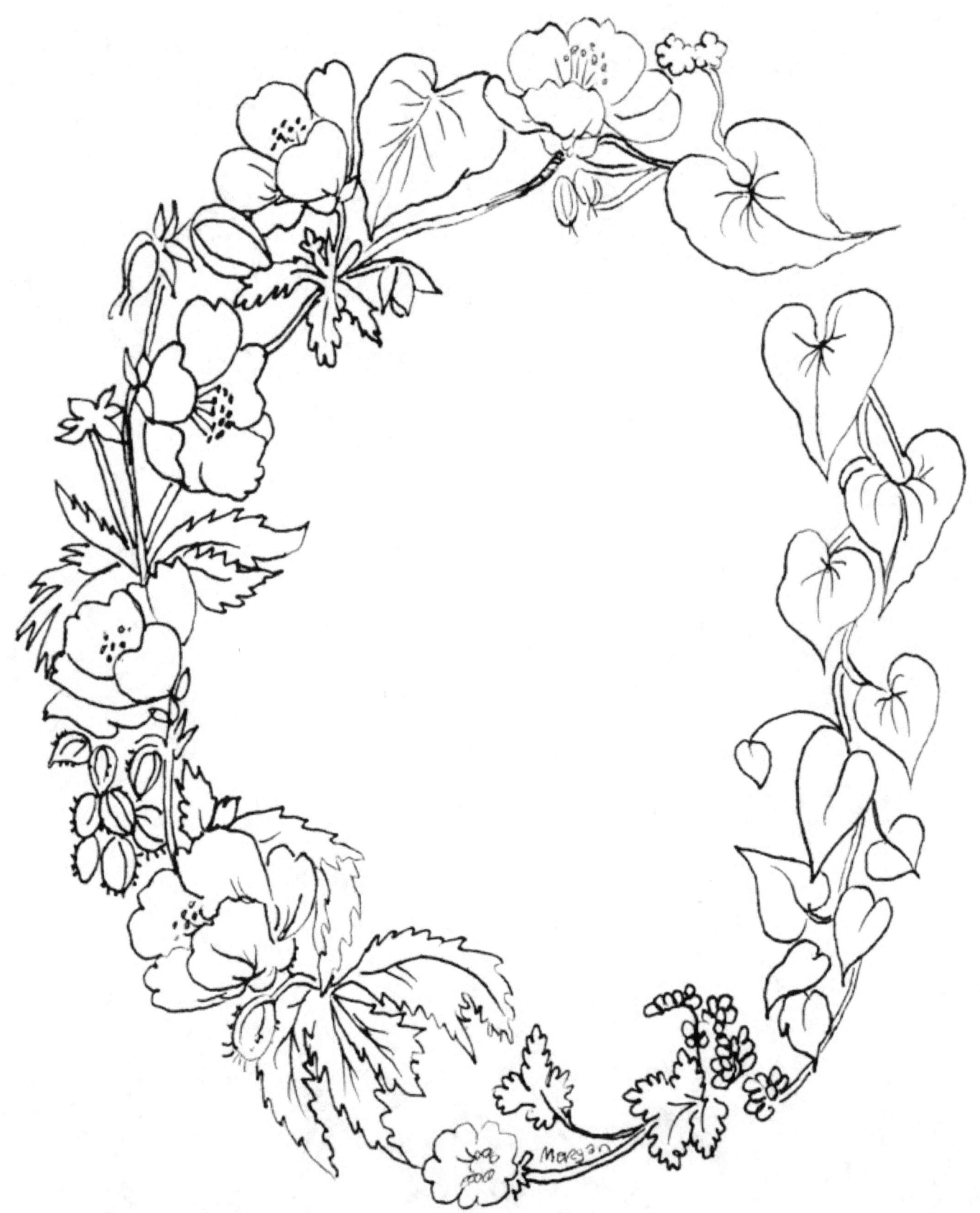

www.ingramcontent.com/pod-product-compliance
Lightning Source LLC
Chambersburg PA
CBHW080644190526
45169CB00009B/3491